IMAGES
of America

SANDY SPRINGS

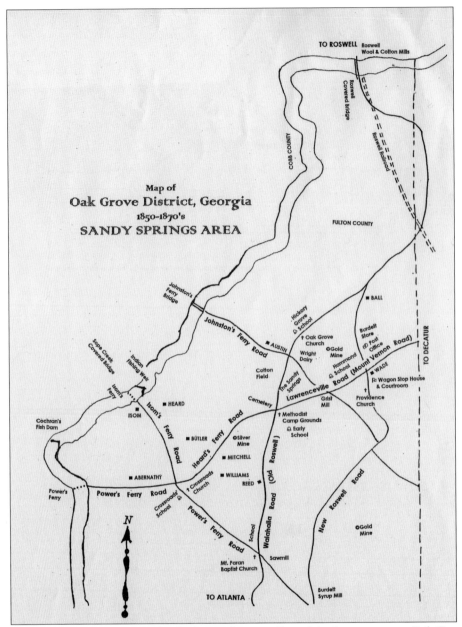

The community of Sandy Springs has had several names. One of the first names was Oak Grove or the Oak Grove District. The map above was created by Emily Junkett to show the general layout of the area during one of its most important growth periods, 1850–1870. Not all of the homes, roads, ferries, or schools are shown, and many names and spellings have changed. Nonetheless, the rural character of Sandy Springs and the roads and trails that supported growth are evident in the map. (Courtesy of Emily Junkett.)

ON THE COVER: Pictured here is a Chappelear family reunion in the early 1920s. The style of clothing indicates that the Chappelears may have been one of the wealthier families in the community. Several generations of the family lived on Powers Ferry Road. (Courtesy of Kevin Smith.)

IMAGES
of America

SANDY SPRINGS

Kimberly M. Brigance and Morris V. Moore
on behalf of Heritage Sandy Springs

ARCADIA
PUBLISHING

Published by Arcadia Publishing
Charleston SC, Chicago IL, Portsmouth NH, San Francisco CA

Printed in the United States of America

Library of Congress Control Number: 2009933225

For all general information contact Arcadia Publishing at:
Telephone 843-853-2070
Fax 843-853-0044
E-mail sales@arcadiapublishing.com
For customer service and orders:
Toll-Free 1-888-313-2665

Visit us on the Internet at www.arcadiapublishing.com

*To my parents, Dan and Lela Brigance, for the guidance
and encouragement that fostered my love of history.*

*To my parents, Hulon and Viola Moore, who loved Sandy Springs
and the families that made this a great place to grow up.*

CONTENTS

ACKNOWLEDGMENTS

Since the founding of Heritage Sandy Springs, hundreds of volunteers have contributed countless hours to collecting and preserving the history of our community. It is impossible to thank all of those volunteers individually, but without their foresight and love of local history, this book would not have been possible. Heritage Sandy Springs's research library and archives are fortunate to be the repository for many local collections. Unless noted, all images appearing in this book were provided by Heritage Sandy Springs.

There are several people who have paved the way for this book through their research, writing, and preservation of local history. Specifically, Lois Coogle, whose books *Sandy Springs Past Tense* and *More of Sandy Springs Past Tense*, have been invaluable resources; Morris Moore, whose strong narrative voice weaves the past and present together throughout this book and without whose knowledge and steady encouragement this work would not have been possible; and Margaret Mobley, Dianne Mitchell, and the members of the Heritage Sandy Springs History and Preservation Committee.

INTRODUCTION

Before Sandy Springs was a city, it was a community. Before that, it was a gathering place. In the beginning, it was simply a local landmark, the place where a natural spring flowed out of the sandy soil.

Native Americans likely first encountered Europeans in northern Georgia in the mid-1500s, when Hernando Desoto explored the region under the flag of Spain. The exact thoughts and feelings of the native people regarding this encounter are unknown to us, but the archaeological record reveals that Desoto and his men left death and devastation in the wake. Unknown to anyone at the time, the diseases introduced by Europeans began a series of destructive events that would end the indigenous way of life.

Some scholars believe that as much as ninety percent of the Native American population succumbed to European disease before the first permanent English settlement in America was founded at Jamestown in 1607. Certainly by 1733, when Georgia was founded, the once powerful Creek Confederacy and Cherokee Nation had diminished in size and political influence. The English settlers in Savannah encountered native people that had interacted with Europeans for more than 200 years and were well versed in the rapacious nature of English settlement. Overwhelmed and overpowered, the native people tried to make the best agreement possible for their lands and hoped for coexistence.

Early English settlers prized the fertile, relatively flat plains of central, southern, and coastal Georgia. Gently sloping land was ideal for cultivating long straight rows of crops. The hilly upland region of Georgia, however, was considered too difficult to farm and was therefore left to the Cherokees and Creeks—for the most part. The borders of Creek and Cherokee lands, though, were never fully respected by settlers or the Colonial or state governments of Georgia. Missionaries, traders, hunters, travelers, and farmers regularly trespassed on Native American lands. The discovery of gold in North Georgia in the early 1800s triggered a gold rush as thousands of settlers swarmed into the lands belonging to the Cherokee. Almost immediately, the Georgia legislature began planning to remove the Cherokee from their land. Through treaty, warfare, and outright removal, the homelands of the Creek and Cherokee were in the hands of the U.S. government by 1840. The most infamous removal was the Trail of Tears of 1838–1839.

In 1821, the former Creek Indian lands were divided into five counties. The counties were then subdivided into districts and land lots. Each land lot was 202.5 acres. Originally, the sandy spring was located in Henry County, but in 1822, DeKalb County was created, encompassing the spring and the surrounding community, most commonly referred to as Oak Grove. In 1853, the future town of Sandy Spring was in Fulton County, which had been carved out of DeKalb.

Seven times between 1805 and 1832, Georgia used a lottery to distribute land. Almost three quarters of the land in present-day Georgia was distributed under the lottery system. Commissioners appointed by the governor would draw the names and lot numbers from two separate drums. For a fee of $19, the fortunate drawer could take out a grant on the lot he drew. The lottery system encouraged agricultural and rural development instead of urban growth. Living on large land lots, families tended to be isolated and self-sufficient. This scattered settlement pattern slowed the development of towns.

Lured by the availability of cheap land, many families migrated along the wagon routes from the mid-Atlantic states, through Virginia and the Carolinas into the new Georgia counties; others traveled north from coastal Georgia and South Carolina. Many settlers received land lots that contained the remnants of Native American settlements and fields, which the settlers immediately converted into building sites for log homes and crops of corn, wheat, and tobacco.

Little hamlets such as Pole Town, Seaborn Town, Groganville, Oak Grove, Sentell, Shallowfords, Oak Shade, Dunwoody, and Roswell merged and overlapped in the mental landscape of residents. Most of these places were small enclaves of different generations of the same family sharing farmland and labor. Later some neighborhoods grew large enough to support a church or school and perhaps a post office and businesses. The majority of the early names of settlements simply died out as smaller settlements blended into larger ones. For more than 100 years, Sandy Springs was a name that loosely described the area around the sandy spring; today Sandy Springs is legally defined and mapped to precision. It is a new city grappling with the ills and blessings of modern urban society

Photographs for this volume have been collected from families, private collections, churches, and libraries. The majority of these images have never been published.

One

MEET THE PEOPLE

For more than a century after its initial settlement, Sandy Springs was entirely rural. After the land was distributed through a lottery in the 1820s, the community remained sparsely settled until the 1940s, with many families continuing to work their 202.5-acre land lots until the middle of the 20th century. For most of its history, the community of Sandy Springs was within the Oak Grove District. A district was a smaller voting or military subdivision of the larger county. As most farmers built their homes towards the center of their acreage, neighbors lived far apart. Most families were subsistence farmers, not the large plantation holders many people associate with the Deep South. Unlike the large plantation owners of the coastal plains, North Georgia residents owned few slaves—just 19 slaves are recorded for the entire district in the 1840 U.S. Census. These names of these enslaved men and women, considered property, were not recorded in the census.

A few enterprising settlers developed additional sources of income, apart from farming, by exploiting the area's abundant natural resources. The mill centers of Marietta, Sope Creek, and Roswell meant a steady stream of travelers crossing the Chattahoochee River. Several ferries served the community, and many roads such as Powers Ferry, Heards Ferry, and Paces Ferry still bear their name. Numerous sawmills supplied the growing city of Atlanta with building material, and their names are still in the landscape, including Grogan's Mill and Henderson's Mill.

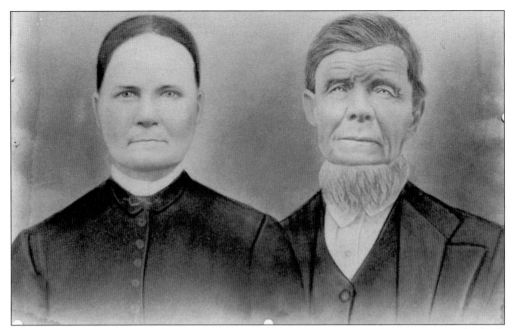

Born in South Carolina, William Collins Austin was the oldest child of John Austin and Elizabeth Copeland. The Austin family settled on the Johnson Ferry Road in the early 1820s. They were one of the first families to settle on the newly distributed land. No doubt their first home was made of rough hewn logs. The original cabin may have been used as a kitchen after a frame house was constructed. A building resembling an early cabin stood on the property as late as the 1980s, but it was torn down to make way for modern subdivisions. Nothing of the John and Elizabeth Austin farm remains in the landscape, but their legacy continues in building and street names throughout the community. Many of their descendents would go on to take prominent roles in the development of Sandy Springs. In this c. 1860 photograph, William Collins Austin is pictured with his second wife, Rebecca Emmaline Hammonds. (Courtesy of Ella Burdett.)

The Austin-Johnson House, as it is now known, is located at 498 Johnson Ferry Road. The farm belonged to Thomas Austin, son of John and Elizabeth Austin and brother to William Austin. Thomas farmed land lot 120 with his wife, Francis Martin, and their children beginning in the 1840s. The current home was likely built around 1900. The Johnson family purchased the farm in the 1930s.

In 1939, Jeannette Johnson (Samples) poses on the porch of the Austin-Johnson House, wearing her high school graduation dress and holding her diploma. Jeannette's parents, Horace and Alice Johnson, purchased the house in the mid-1930s so that she could attend North Fulton High School. Previously, the Johnsons had lived in Cobb County. (Courtesy of Jesse Ford Samples and Shirley Samples Arditti.)

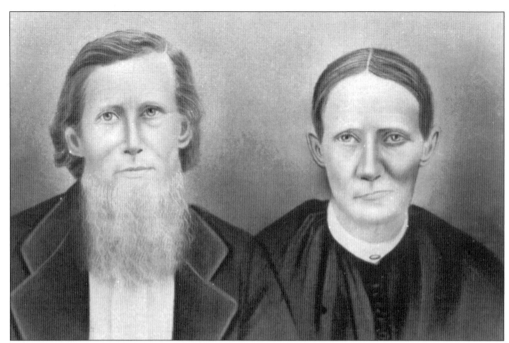

Like many in search of cheap, available land, Thomas and Hannah Abernathy Burdett moved from South Carolina to the Sandy Springs community in the 1830s. This image is believed to have been made in the 1860s. Hannah Burdett may have suffered a stroke that caused one side of her face to be partially paralyzed. (Courtesy of Burt Terrell.)

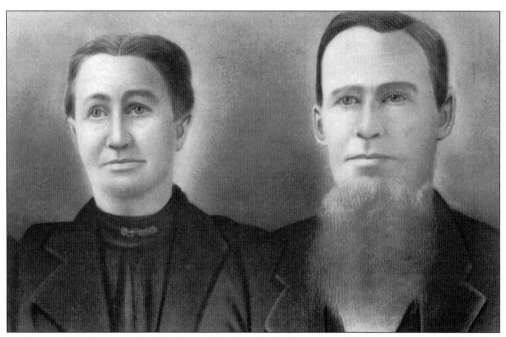

In this *c.* 1880 photograph, John Franklin Burdett is shown with his first wife, Martha. John Franklin was the son of Thomas and Hannah Burdett. (Courtesy of Burt Terrell.)

John Franklin Burdett was photographed
with his second wife, Carrie, around
1880. (Courtesy of Burt Terrell.)

The family of Luther Isaac and Edna Carpenter Burdett are, from left to right, Forrest W. Burdett,
Edna Carpenter Burdett, Bertha Burdett Townsend, Luther Burdett, and John Franklin Burdett.
This c. 1902 photograph was taken at the family home, near Carpenter Drive.

13

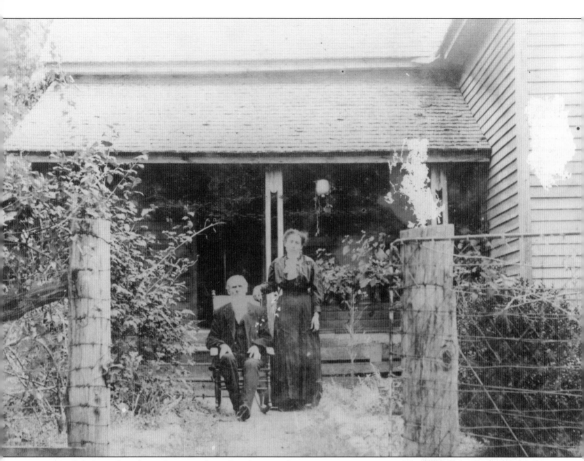

Stephen Burdett (seen here with wife Alice at their Mount Paran Road home around 1910) started the Burdett Grocery at the crossroads of Roswell Road and Mount Vernon Highway. The store would go on to become one of the cornerstones of Sandy Springs business and at different times housed a post office, dentist, and doctor's office in addition to selling groceries. The Burdett's frame house was replaced by a brick home in the 1930s.

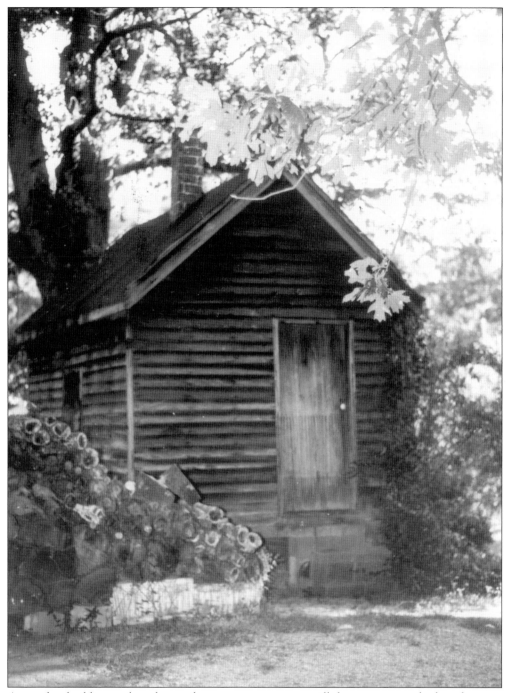

A wooden building—altered over the years to serve as a milk house, storage shed, and even a temporary home—was donated to Heritage Sandy Springs by Ed and Emily Montalvo, who have owned the Burdett Farm since the 1960s. The structure was moved to Heritage Green in 1990, where it has a place of honor in the garden. (Courtesy of the Montalvo family.)

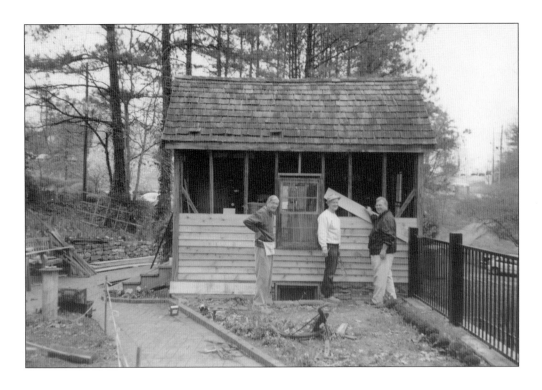

Guy Berger, Robert Stowell, Joe Bond, and Herb Daws worked to reconstruct the milk house at the Heritage Green site in 1999.

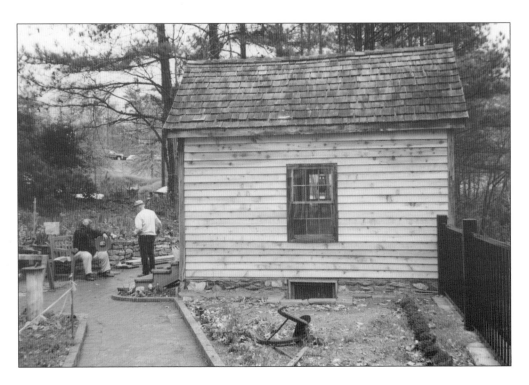

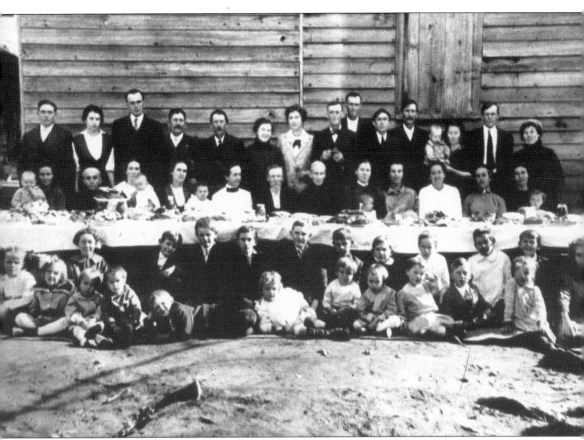

In 1915, the family of John W. Ball celebrated John's 75th birthday with a party, pictured here. The photograph was taken at his home, on the current 7000 block of Roswell Road. John W. Ball was the son of Peter and Margaret Robertson Ball of Laurens, South Carolina. Like many other South Carolina families, the Ball family became prominent in the Sandy Springs community.

John W. Ball is pictured with his wife and unidentified others. Wedged between a car dealership and Big Trees Preserve, the John W. Ball Cemetery is all that remains of the former Ball family farm on Roswell Road. (Courtesy of Kevin Smith.)

John W. Ball (shown here on his 75th birthday) married Margaret Adams on December 28, 1865—eight months after mustering out of the Confederate army at Appomattox Courthouse, Virginia, with the rank of full corporal. John W. Ball died August 5, 1920.

John Ceroma Ball and Hulda Isom Ball are shown in their garden in 1920. John Ceroma Ball was the grandson of Peter Ball, one of the original recipients of the land lottery. He was the son of Martin and Martha Sentell Ball, a cousin to John W. Ball. He married Hulda Jane Eison in 1877. Like most family names, Eison has many spellings, even within the same family: Eison, Ison, Isom, and Ishom are all recorded in local deeds and wills. The couple had eight daughters—Dora Isabell, Maggie, Mima Lavada, Martha Elizabeth, Lena R. Meda, Jessie Alma, and Minnie Lee—and one son, Marvin T.

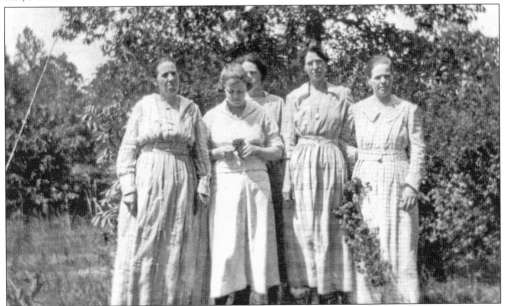

Shown here are five of the eight daughters of John Ceroma and Hulda Isom Ball Miona Ball. From left to right are Mabry, Minnie Ball Smith, Maggie Ball Covington, Dora Ball Mitchell, and Jessie Ball.

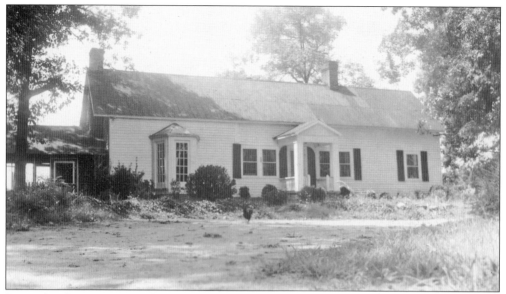

Located at the intersection of Johnson Ferry Road and Glenridge Drive is the Wagon Stop House, built by the Wade family sometime before 1854. In addition to being a well-known resting place, the home was also used to hold local court for many years. The home has undergone several renovations, and only one room of the original structure remains part of the house as it stands today. This photograph was taken in 1940.

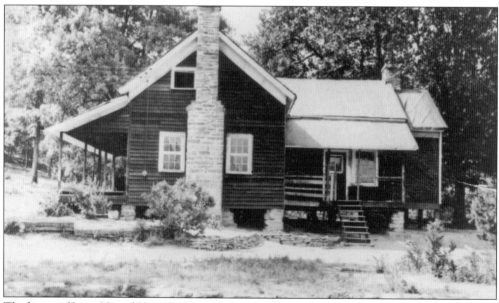

The home of Isaac H. and Katie Wilson was located near Glenridge Drive and Aberdeen Forrest from the time of the Civil War until his death in 1904. The home also served as a store and post office for many years. At that time, the community was also called Hammond. The structure survived for many years but was demolished for a modern home in 2005.

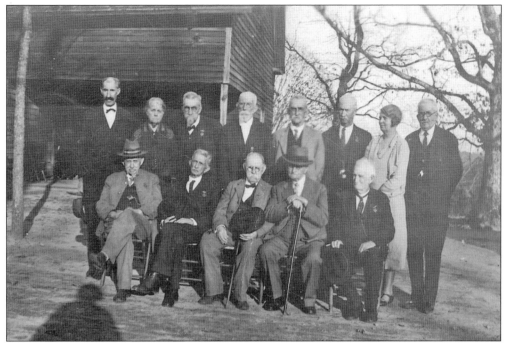

This photograph is believed to show Wesley Harris Mitchell (second row, fourth from left) and several other Confederate veterans at a reunion held at his home. The Oak Grove/Sandy Springs community was not large enough to muster an individual unit, so the local boys were obliged to join regiments in Roswell, Marietta, and Decatur in order to fight what they termed the War of Northern Aggression. (Courtesy of Betty Copeland McGhee.)

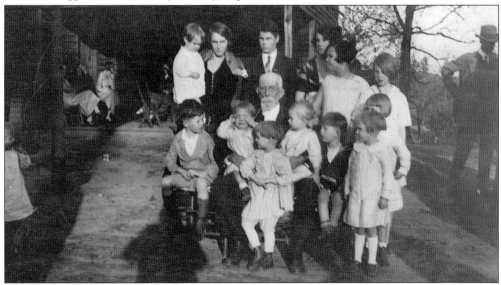

Here Wesley Harris Mitchell is photographed with several of his grandchildren. Photography was still a relatively new technology to the rural population of Sandy Springs. Even after 1900, few could afford to have film developed, even if they were able to buy a camera. A special occasion, however—an important birthday or reunion—might be special enough to have several photographs made. (Courtesy of Betty Copeland McGhee.)

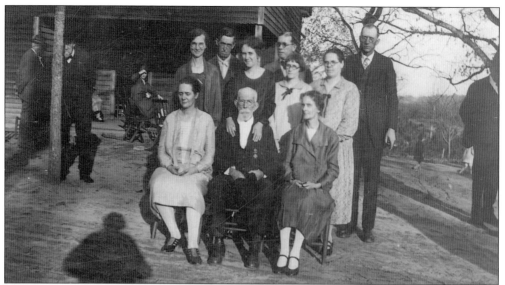

This photograph was taken at the Reed-Mitchell home in 1928. The house was built by Wesley Harris Mitchell's father-in-law Nathanial Reed. Wesley Harris Mitchell moved to the home after his marriage to Arcane Reed. The house was moved to the corner of Long Island Drive and Mount Vernon Highway when Interstate 285 was constructed. Pictured are, from left to right, (first row) Cora Cooper, Wesley Harris Mitchell, and Ida Davai; (second row) unidentified, Maranda Mitchell, unidentified, and Dora Mitchell; (third row) unidentified, George Mitchell, and Lon Mitchell. (Courtesy of Betty Copeland McGhee.)

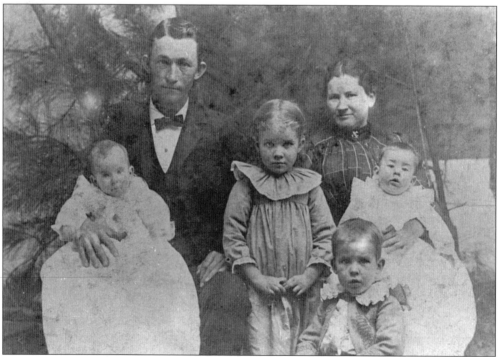

Records indicate many of the Reed family lived near the little community of Crossroads. John Nathanial Reed was prosperous enough to have this family portrait made in the late 1800s.

Alonzo (Lon) Mitchell, the son of Wesley Harris Mitchell, built his house up the hill from the family home. The path between the two houses eventually became a road and is still in service as Mitchell Road.

Three of Lon Mitchell's sons are pictured in this *c.* 1929 photograph. From left to right, they are Dave, Henry, and Marvin Mitchell.

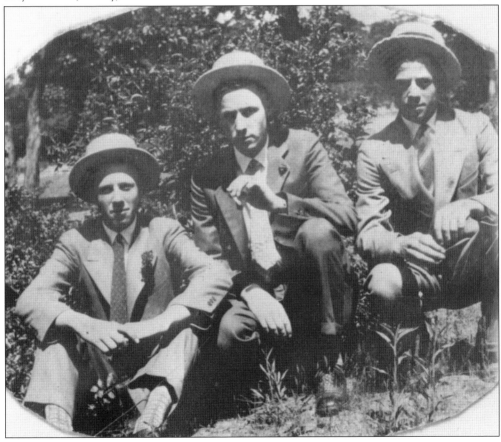

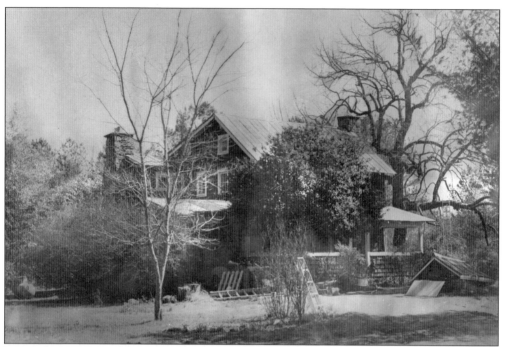

Located near Mount Vernon Highway and Glen Errol Drive, portions of this home may date back to 1822, when Thomas Mitchell drew land lot 134 in the Georgia land lottery. James Tiller purchased the house in 1892. (Courtesy of Janet Tiller.)

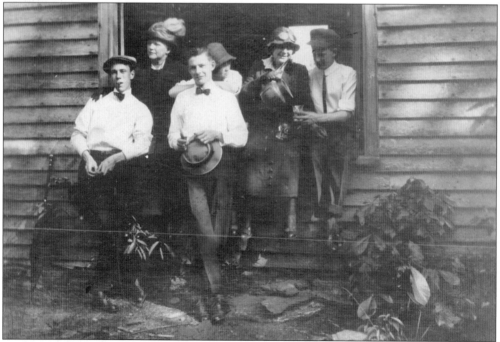

Frank Tiller (far left), Lucia Arnold Tiller (mamma), Mary Tiller (Lewis), Blossom Tiller, John Courtney, and J. D. Tiller are pictured at the old shop place in 1913. The old shop place was most likely the blacksmith shop or school in the Crossroads community. (Courtesy of Janet Tiller.)

Mary Tiller is pictured here in her bathing costume and tights at her home near Mount Vernon Highway around 1915. (Courtesy of Janet Tiller.)

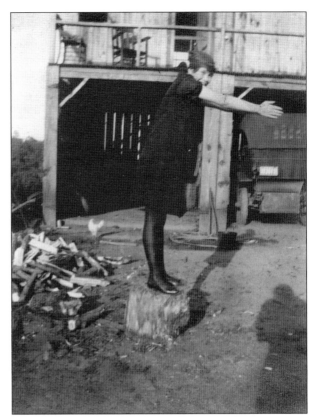

Vivian Tiller, Frank Tiller's wife, is pictured in front of the smokehouse at the Tiller home. The bloodhound on the left was named Little Claude, and the Fox Terrier was named Jack. According to the family, both dogs were quite spoiled. They were often fed milk and corn bread and, as seen here, were always the center of attention. (Courtesy of Janet Tiller.)

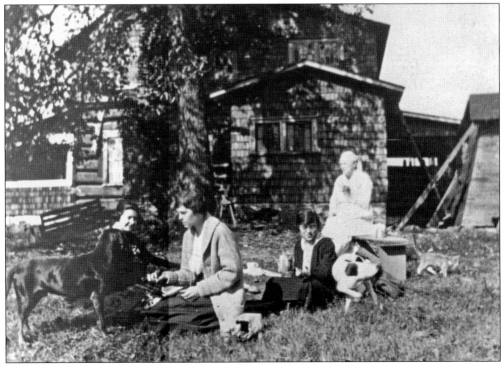

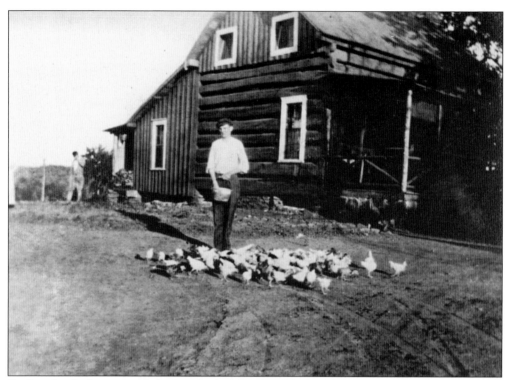

Feeding the chickens was a daily chore for farm families. The home's log construction is clearly visible in the photograph. The use of logs, instead of sawmill cut boards, indicates that the Mitchell–Tiller house may be one of the oldest homes in Sandy Springs. (Courtesy of Janet Tiller.)

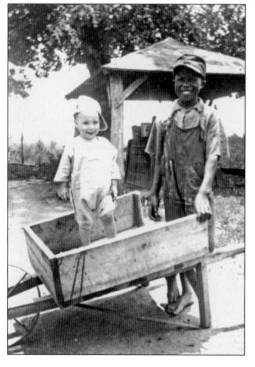

Frank Tiller Jr. (left) and friend are seen here playing in the family's front yard. At age 21, Frank joined the U.S. Army where he eventually reached the rank of colonel. (Courtesy of Janet Tiller.)

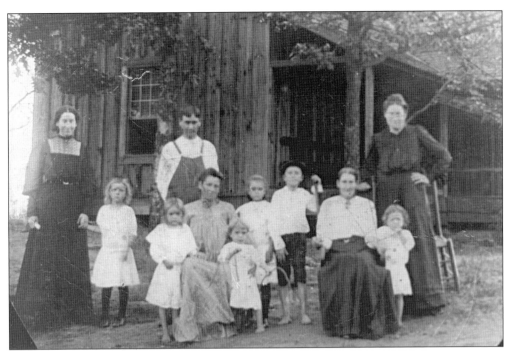

Belle Spruell (Ezzard) is shown here (extreme left) with her mother (extreme right), her two sisters, and their children. The photograph was made in front of the old home place near Roswell Road and Belle Isle Road about 1905. The Spruell family name has many different spellings, including Spruill, Spruil, and Spruelle. The family owned many large tracts of land in Sandy Springs and Dunwoody, and the name is still common in the area. At one time, Stephen T. Spruill owned land stretching from Long Island Creek to Mount Vernon Highway. His great-grandson and namesake, Stephen Spruill, continued to own land along Mount Vernon Highway until his death in 1967.

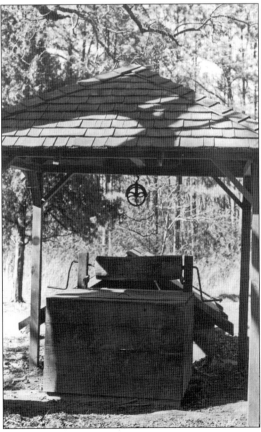

This image shows the Ezzard family wells. The name of the road where the family lived was changed from Ezzard Road to Northland Drive by developers and homeowners who wanted a more commercial-sounding name. Thomas Ward Ezzard moved to the area of Northland and Highpoint Road around 1895. Thomas was the nephew of William Ezzard, twice the mayor of Atlanta.

27

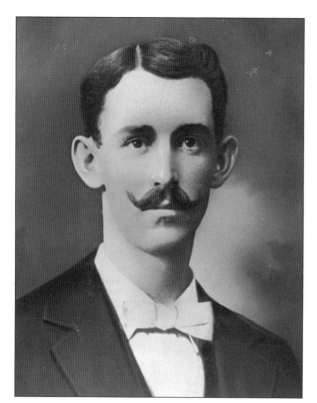

Edwin Ezzard (1873–1902), son of Thomas Ward and Louvinia Mansell Ezzard, died of mysterious and heretofore unknown causes at West Point Military Academy.

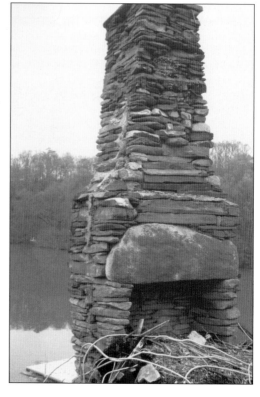

Records indicate this chimney is all the remains of the home of pioneer Joseph Power (1780–1875), located at Morgan Falls Park. The family operated a ferry that crossed the Chattahoochee River near this site for several years. Joseph's son James later operated the more famous Powers Ferry several miles downriver. James Power lived in Cobb City.

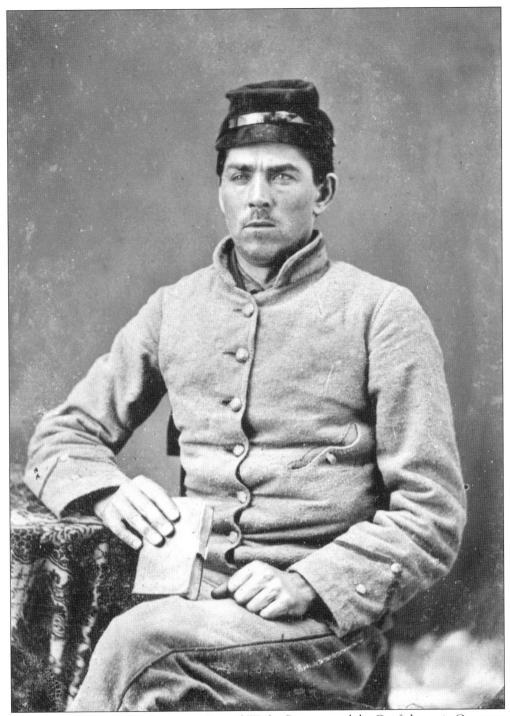

Like several men from Sandy Springs, Samuel Wesley Power served the Confederacy in Company B, 9th Battalion, Georgia Artillery. He was the son of James Power. (Courtesy of Kevin Smith.)

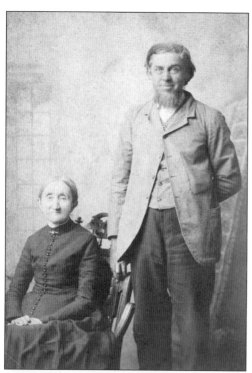

This photograph shows Samuel Wesley Power with his wife, Mary Ann Hopkins Power. Samuel's father, James, operated the Powers Ferry across the Chattahoochee from Cobb to Fulton County. James made his home on the Cobb County side of the river. (Courtesy of Kevin R. Smith.)

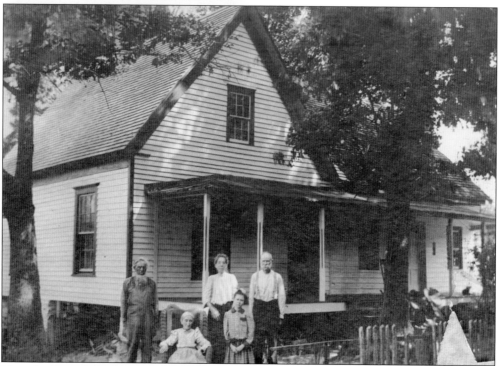

Here the Samuel Wesley Power family is pictured in front of the family home on Power's Ferry Road. From left to right, the family members are Samuel Wesley Power, Mary Ann Hopkins Power, Liza Power Robinson, Anne Robinson, and Young Robinson. (Courtesy of Kevin R. Smith.)

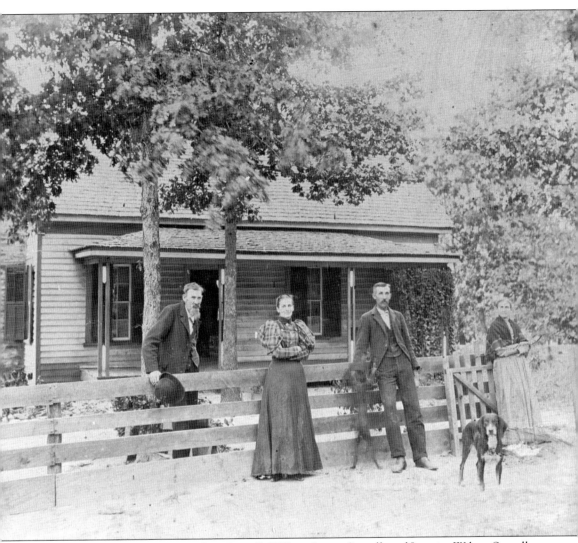

James M. Sentell, Rose Anna Wilson Sentell, William Jasper Sentell, and Louvisa Wilson Sentell pose in front of the family home on Roswell Road near the area of Mystic Drive around 1897. Like most men in the area, James fought for Southern independence in the Civil War. (Courtesy of Helen Sentell Gilleland.)

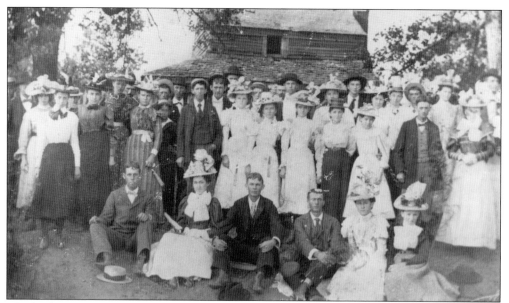

The back of this photograph reads: "Sunday at the Owens family home 1898." For several years, the Owens family owned the sandy springs site. Today their home would be located on Mount Vernon Highway midway between Sandy Springs Circle and Roswell Road, approximately where the Target store was located until 2008 and where the future Sandy Springs City Hall is planned. (Courtesy of G. R. Mitchell.)

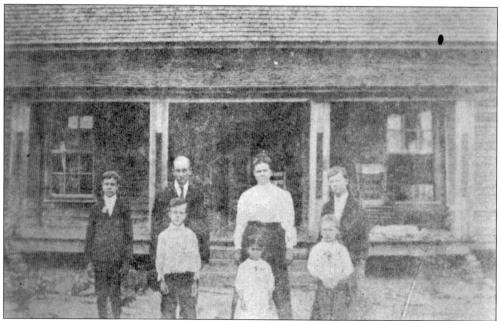

Walter Jerome Williams was still a DeKalb County resident when he purchased the south half of land lot 19 in October 1878. A small, two-room home may have been on the property when he purchased the land, or he may have had it constructed before he moved his family to the area in the early 1880s. The home had already been altered dramatically before this photograph was made.

Walter Jerome and Harriet Austin Williams sit on their porch, about 1930. Harriet Austin Williams was born the year the Civil War ended, lost at least one son in World War I, and died with days of her husband in 1936. The Williamses are buried in the Sandy Springs Methodist Church Cemetery. Like their neighbors, the Williamses did not have electricity or indoor plumbing.

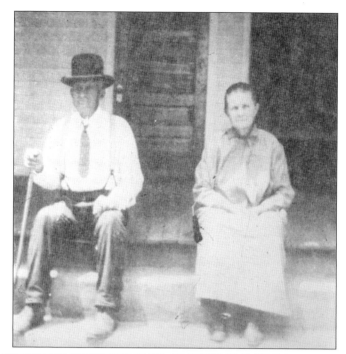

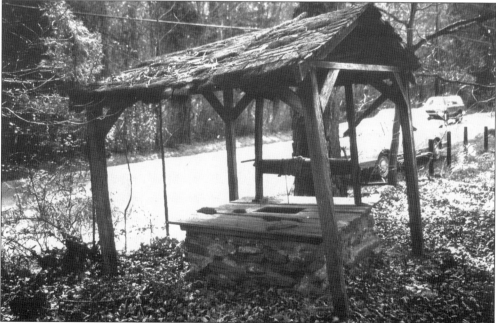

Obediah B. Copeland served as a private in Company A, 38th Georgia Regiment Wright's Legion, Murphy's Guard. He was wounded at Sharpsburg and later captured defending Roswell, Georgia, on July 9, 1864. He was taken prisoner and imprisoned at the notorious Camp Douglas, Chicago, Illinois. He survived his incarceration, and after the war, he and his wife, Salina, built a home on Roberts Drive where they farmed, and operated a general store, cotton gin, and a post office called Grogansville. The well, the last remnant of Obediah's plantation, was demolished to make way for Dunwoody Springs Elementary School.

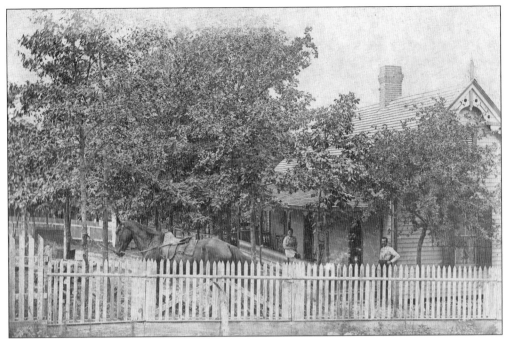

Ferdinand J. Chappelear and his wife, Eula Lyle Chappelear, lived with their family on the Powers Ferry Road. The Chappelear family is one of the oldest in Sandy Springs. Like the Spruill family, the spelling of the family name has varied. Unfortunately, their home no longer stands. (Courtesy of Kevin R. Smith.)

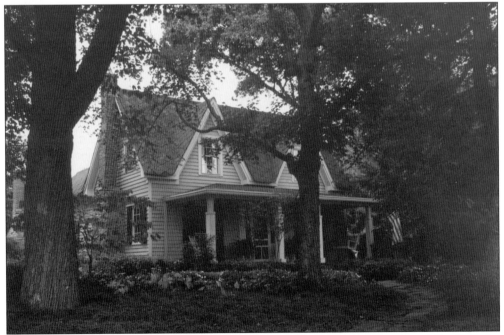

In 1854, Charles and Caroline Woodall built their home on the Nesbitt Ferry Road. By 1860, the Woodalls had five children. The family farmed with the help of 10 slaves. This is a modern photograph of the home. (Courtesy of Lynne Byrd.)

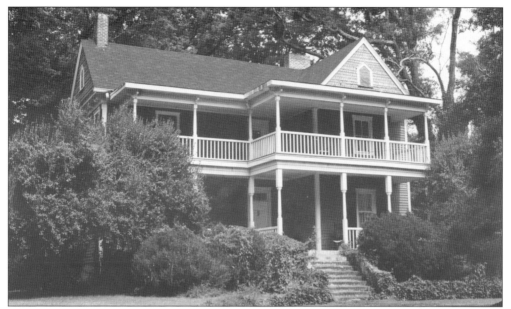

The Roberts house was built in 1894 by Isaac Roberts. He served as engineer of the Roswell Railroad from 1880 to 1921. Roberts was the sole engineer in the railroad's history and was instrumental in the construction of the Bull Sluice Railroad that served Morgan Falls, the site of Atlanta's first hydroelectric power generating plant. Roberts was also founder of the Roswell Bank and served as director until his death in 1930. (Courtesy of Lynne Byrd.)

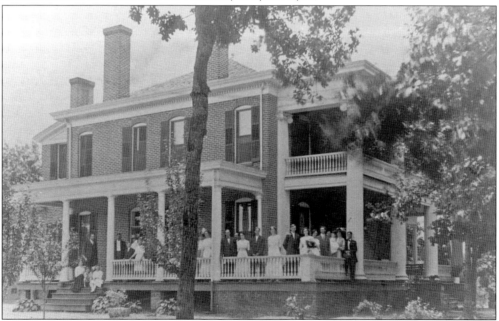

The Benjamin Franklin Burdett home was built on Mount Vernon Highway about 1900. It was one of the first brick homes built in the community. The home hosted many lavish social events. Mrs. W. F. Winecoff, of the famous Winecoff Hotel in Atlanta, purchased the property in 1916. The property changed hands many times and was eventually demolished to build Mount Vernon Presbyterian Church.

Benjamin Franklin Burdett (1861–1935) had this photograph made with his wife, Jennie Reed Burdett (1867–1927), in the mid-1920s. He was the founder of Burdett Realty Company and the son of Isaac Burdett.

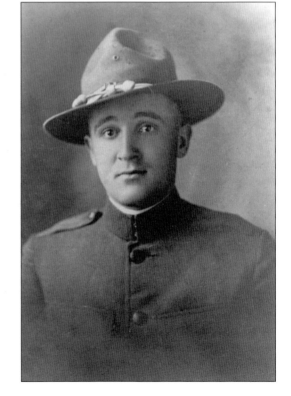

John Franklin Burdett was the third child of Luther and Edna Burdett. After two years of study at Oglethorpe University, he enlisted in the U.S. Army and served until the end of World War I. This 1917 photograph shows him in uniform.

Nannie Lou Nance, a lifetime resident of Sandy Springs, met John Franklin Burdett at a church singing, which provided an opportunity for young people to socialize in a casual but supervised environment. The couple married in 1919 at the home of his uncle, Stephen Burdett, on Mount Paran Road. The couple lived for many years on Glenridge Drive.

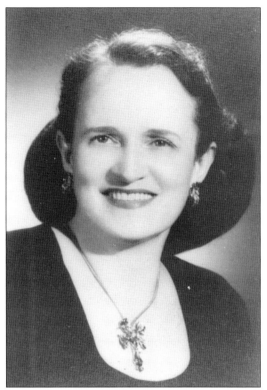

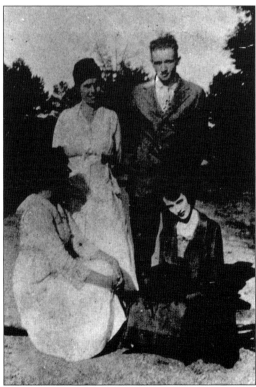

John Franklin Burdett is standing in this photograph; Nannie Lou Nance Burdett has the dark hat. The image likely dates to the 1920s.

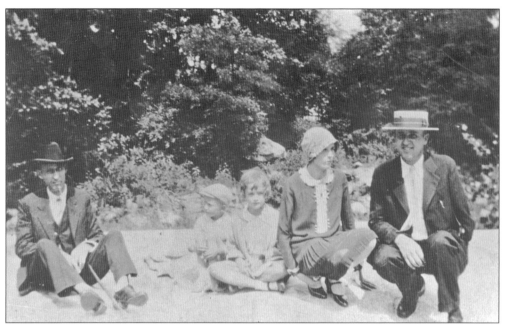

This photograph shows, from left to right, Stephen, Jimmy, Christine, Nannie Lou, and John Franklin Burdett, presumably on the banks of the Chattahoochee River. The Chattahoochee was the main recreational outlet for area families, providing fishing, swimming, and picnicking opportunities as well as scenery for practicing the relatively new hobby of photography.

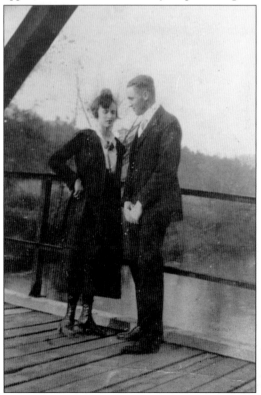

Nannie Lou Nance and John Franklin Burdett seem to be standing on either the Powers Ferry Bridge or the Johnson Ferry Bridge. In the early 1900s, the construction of bridges to replace ferries and the introduction of automobiles opened the once isolated community to previously unknown social and economic opportunities.

Pictured in this photograph is
Minnie Hilderbrand Ferguson.

Eva (sitting) and Irene Hilderbrand.
The Hilderbrands were a prominent
Sandy Springs family, and Hilderbrand
Drive is a remnant of the family's
long legacy in the community.

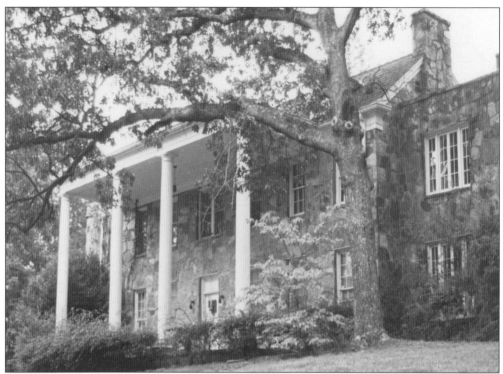

Dr. Daniel H. Griffith, a prominent Atlanta ear, nose, throat, and eye doctor, began constructing his Sandy Springs home in 1929 on land he had purchased from the Heard family. A road constructed to the river allowed river stone to be quarried and brought directly to the building site. Dr. Griffith later opened the first pharmacy in Sandy Springs. The home took three years to construct, and stayed in the Griffith family until the 1970s. (Courtesy of Bernadine and Jean-Paul Richard.)

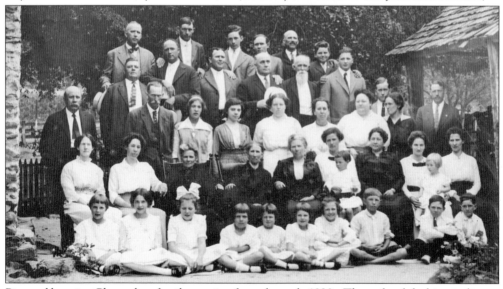

Pictured here is a Chappelear family reunion from the early 1920s. The style of clothing indicates this may have been one of the wealthier families in the community. Several generations of the family lived on Powers Ferry Road. (Courtesy of Kevin Smith.)

Coca-Cola tycoon Asa Candler, like several Atlanta businessmen, built a summer home in Sandy Springs. Located on Northland Drive, the home was built in the rustic cabin style popular at the time. A spring-fed swimming pool offered cool relief on hot days. The property also included pastures and barns for their many horses.

The Guilbert family was representative of many affluent Atlanta families that had summer homes in Sandy Springs. They lived on Spalding Drive.

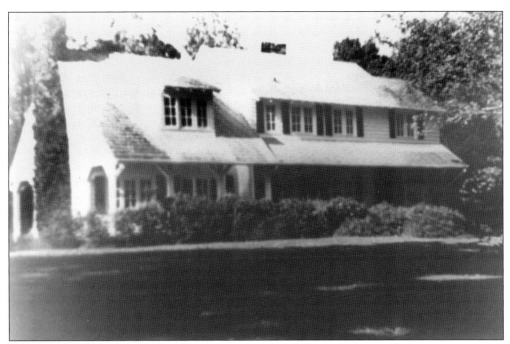

The Bondurant home was located at the present site of Northside Hospital.

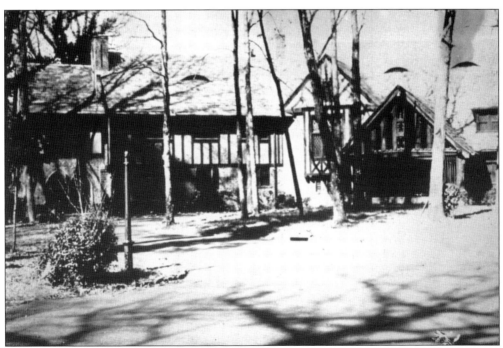

Glenridge Hall is arguably one of the most beautiful homes in Sandy Springs and one of the few local properties listed on the National Register of Historic Places. The home was built in 1928 for Thomas Kearny Glenn and his second wife, Elizabeth Ewing. It was designed by renowned architect Samuel Inman Cooper.

In 1892, Atlanta realtor James Tiller bought the Mitchell home near Glenn Errol and Mount Vernon Highway. The house was used for many years as a second home or summer house for the family. In 1913, Lucia Tiller, James's widow, made the home her year-round residence. (Courtesy of Janet Tiller.)

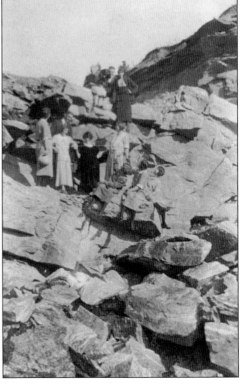

The Tiller family enjoyed photography. This was taken on one of their outings to a local quarry. There were at least three quarries on Lake Forrest Drive; this photograph was likely taken at one of them. (Courtesy of Janet Tiller.)

Betty Hilderbrand strikes a glamorous pose at the well in front of the Hammond School around 1935. (Courtesy of Janet Tiller.)

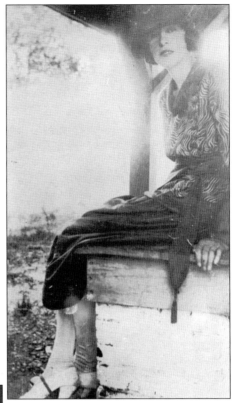

Here is young Marianne Tiller, wearing what the well-dressed baby wore in 1921. Marianne was the daughter of Jim and Jean Tiller. (Courtesy of Janet Tiller.).

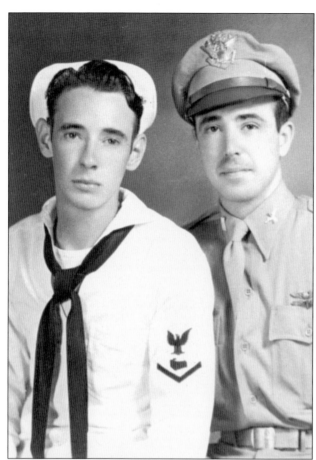

The Tiller boys, like many in Sandy Springs, fought bravely for their country in World War II. J. D. Tiller (left) served in the U.S. Navy while Frank Tiller Jr. (right) became a colonel in the U.S. Army. (Courtesy of Janet Tiller.)

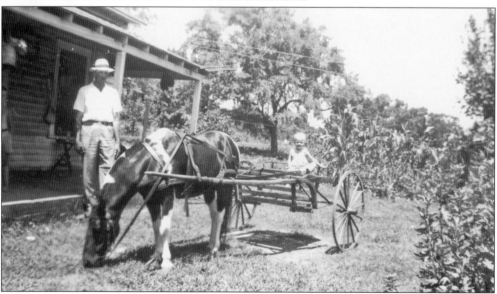

Alan Sentell took great pride in his horse and cart. This 1948 photograph captures him outside his home on West Belle Isle Drive. (Courtesy Helen Sentell Gilleland.)

Members of the Sentell family lived for many years near the present intersection of Interstate 285 and Peachtree-Dunwoody Road. This 1968 photograph shows the home's chimneys, all that remained of the home, with Interstate 285 in the background. (Courtesy Helen Sentell Gilleland.)

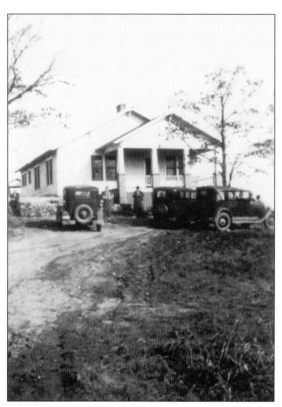

This *c.* 1931 photograph shows the home of William Jasper and Rose Anna Sentell on Roswell Road, just north of Belle Isle Road. (Courtesy Helen Sentell Gilleland.)

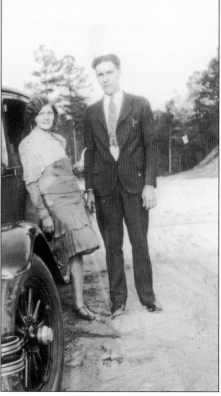

Pauline "Polly" Henry and George Elvin Coleman pose in 1929 beside an automobile. As in the rest of the country, automobiles were a rage with young people in Sandy Springs. Not only was it fun to traverse the country roads, but an afternoon drive also gave young couples a chance to be together without a chaperone.

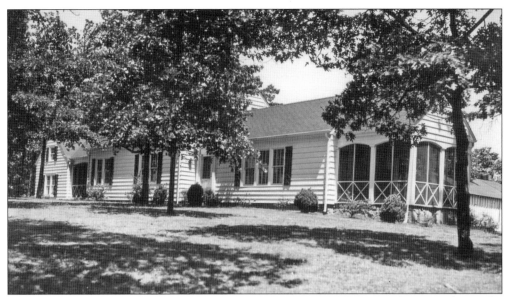

The home of George Elvin and Polly Coleman at 1255 Mount Vernon Highway stood near the DeKalb County line. The home did not have a telephone or indoor plumbing for many years. Even in the 1930s, Polly Coleman washed her family's clothes by scrubbing them on a washboard and boiling them in a large kettle.

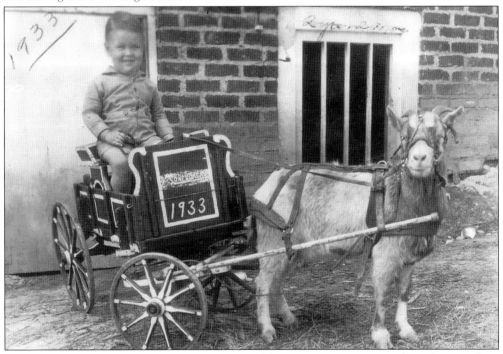

Young George Elvin Coleman Jr. is photographed here in a goat cart. Traveling photographers often used props like a goat cart to entice rural parents into purchasing photographs. Luckily, traveling photographers did not usually carry a dependable flash or light source, so images were often made outside in front of houses, gardens, barns, or other structures that would otherwise go undocumented.

From left to right, Richard, George Elvin Jr., Larry, and Bobby Coleman pose outside their home on Mount Vernon Highway. When Polly and George purchased their home from C. A. Puckett, Polly's mother commented, "Oh my goodness, [Sandy Springs] is the backside of nowhere." The Coleman home was renovated and remodeled many times before being demolished in the 1970s. George Coleman developed many properties in Sandy Springs, including the Underwood Hills neighborhood near Abernathy Road. From 1946 to 1958, George Coleman and business partner Lon M. Bridges owned the property where the sandy spring is located.

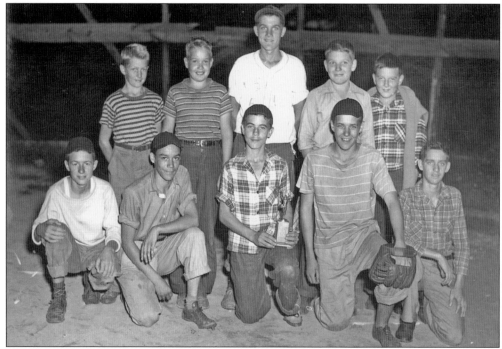

Many baseball games were played at Sandy Springs's unofficial ballpark, which was bounded by Roswell Road, Boyleston Drive, Hammond Drive, and Mount Vernon Highway. This 1940s photograph shows, from left to right, (first row) Bill Sewell, Carl Jameson, Al Holbrook, George Coleman, and Hubert Nix; (second row) Charles Sewell, Billy Hair, Doyle Mabry, Richard Coleman, and Richard Johnson.

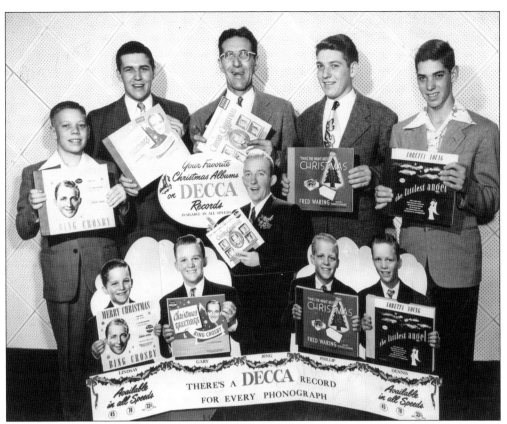

George Coleman (center) poses with his sons, from left to right, Richard, George Jr., Larry, and Bobby after winning a Bing Crosby and sons look-alike contest in the 1940s.

James Francis "Jim" Hardegree (in uniform) and Hugh Sentell stand in front of the Hardegree home on Peachtree-Dunwoody Road during the summer of 1944. John Hardegree, Jim's great-grandfather, came to the area in the late 1800s. In 1883, he married Catharine Elizabeth Dalrymple at her parents' home on Dalrymple Road in Sandy Springs. (Courtesy of Kathy Hardegree.)

Major and Marie Payne were photographed early in their marriage. In addition to restoring the Williams-Payne house, Marie Payne was active in local society, contributing her time and talents to garden clubs and various cultural societies. Major Payne operated a real estate business.

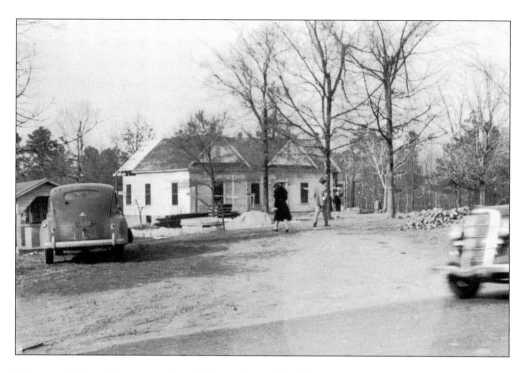

Major and Marie Payne purchased the Williams farmhouse in the early 1940s. After moving it nearly 80 feet farther back from the recently widened Mount Vernon Road, they extensively remodeled the house inside and out, including adding a basement, removing the front porch, adding rooms, and rearranging the placement of walls, doors, and windows.

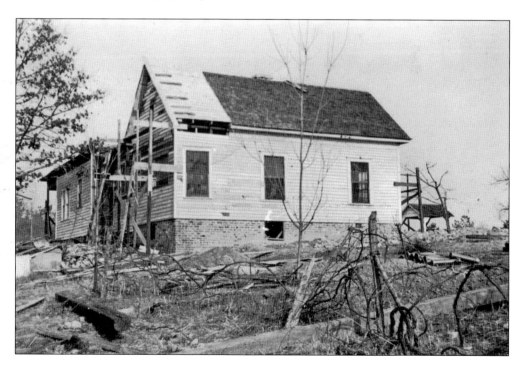

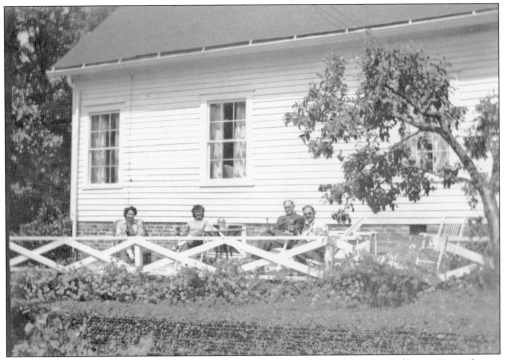

After renovating it, the Paynes lived in the home for several decades. The Williams-Payne home was relocated to Heritage Green in the mid-1980s, where several elements of the home from different time periods were reconstructed.

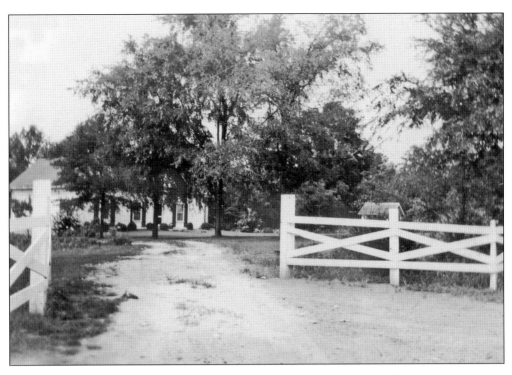

Marie Payne volunteered for several charitable organizations in the Sandy Springs area, most notably on the board of award-winning garden clubs and civic groups. She often entertained at her home on Mount Vernon Highway and continued hosting social events after she relocated to Aberdeen Forrest. These photographs show the house as it looked in the 1950s after the Paynes' renovations and additions.

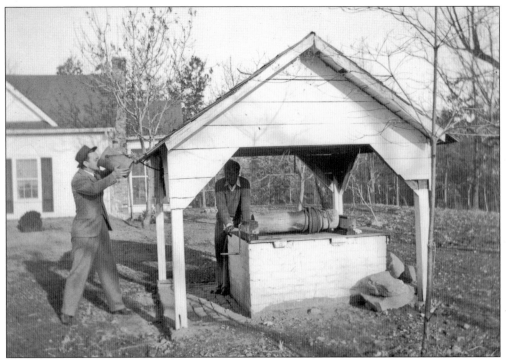

Major Payne entertains a guest at the well of the Williams-Payne home in the 1950s. The Williams family had at least two wells on their property. One was in the front of the home and the other was behind the house, closer to the back porch.

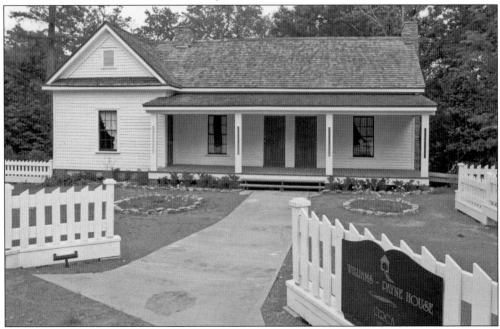

The reconstructed Williams-Payne House is seen as it looks today at Heritage Green in Sandy Springs. The home now houses a permanent exhibit, Sandy Springs: Land and People, as well as two changing exhibit spaces that display various aspects of the community's rich and complex history.

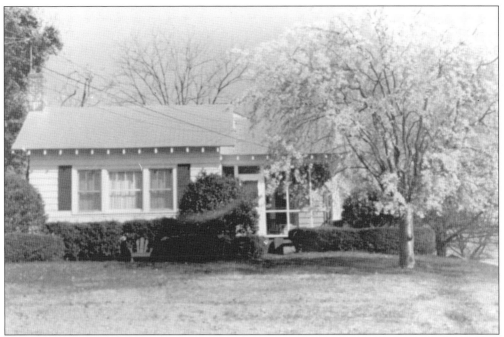

This photograph shows the Roy Lewis home on Mount Vernon Road in the 1960s. Lewis was the local barber, and his home was located about where the Waffle House on Mount Vernon Highway is today. His barbershop was on Roswell Road where the Color Tile store stands. Women had their hair cut across the street, at Irene Burdett Maddox's beauty shop.

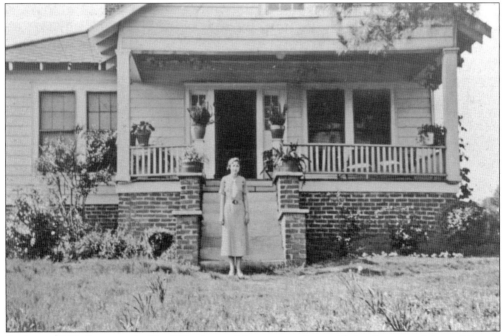

In this *c.* 1940 photograph, Opal Hardeman Morgan stands outside her home on Mount Vernon Highway, about where the Goodwill Store stands today. Opal's father-in-law, J. T. Morgan, served as justice of the peace for many years in Sandy Springs.

Mary Baker was known as the flower lady. She lived on Mount Vernon Highway, west of Roswell Road. In addition to an abundance of flowers, her hilltop acre had an apple tree, plum trees, and a fig bush, which often supplied choice fruit for sale at Burdett's Grocery Store.

Shown here is the home of Maurice Burdett Womack (1915–1977) and Katharine Moore Womack, located at 6031 Roswell Road. Sandy Springs Plaza now occupies the land. Maurice was the son of Tilly E. and Ora Burdett Womack. He was inspired to develop the shopping center after he and his family traveled across the country in 1956 to attend a Rotary International Conference in San Francisco.

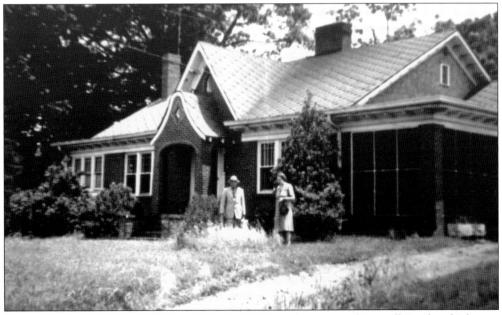

Pictured is the Tilly Ebenezer Womack house (1920) at the corner of Roswell Road and Johnson Ferry Road. Tilly E. Womack was born in 1886, the youngest child of E. Prestley Womack and Sara E. Bolton. Tilly married Ora Burdett (1891–1945), the daughter of Benjamin Franklin and Jennie Reid Burdett, in 1912. The house was demolished to make way for the Sandy Springs Plaza Shopping Center in 1958.

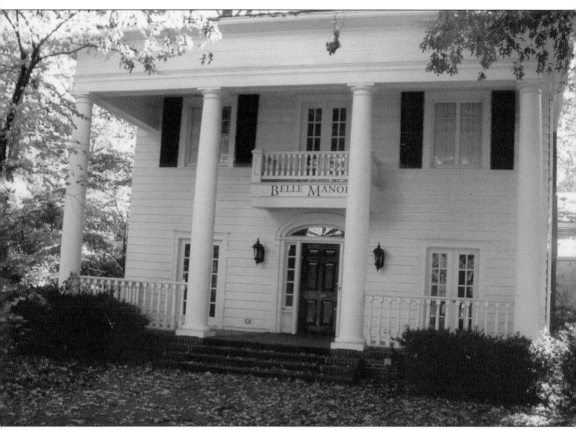

The Butler House, or Belle Manor as it is often called, is one of the last remaining stately homes on Roswell Road. Built in the 1920s, the home recalls the Greek Revival architecture associated with antebellum Georgia. The yard includes large trees and heirloom plants. Situated at 5229 Roswell Road, the home is just north of the historic communities of Pole Town and Oak Shade.

Two

OLD SOUTH TO NEW SOUTH

Sandy Springs, like the rest of the United States, suffered greatly during the Depression. One steady job, if one was fortunate enough to get it, was as a guard or an office worker at the convict camp located near what is now Roswell Road and Hammond Drive. When convict labor was phased out in the 1940s, Sandy Springs's prime source for non-agricultural employment disappeared. However, the United States soon found itself in World War II, and things began to change rapidly in the community.

The Second World War transformed Sandy Springs from a rural village into a bustling suburb. Many young men and women left farms to serve in the military. For many, it was the first time they had been paid wages. The Bell Bomber plant in Marietta employed hundreds, and Atlanta industry boomed. Developers soon realized that Sandy Springs's farms and dairies could be converted into neighborhoods and strip malls to meet the growing demands of the new middle class.

At war's end, young families began moving into the affordable new suburb of Sandy Springs. Standardized building materials meant that entire neighborhoods with dozens of homes could be constructed in a matter of months. The modern homes, outfitted with running water and electricity, brought a new standard of living to the former rural enclave.

Bill, Dad, Susan, Harvey in living
rm. of Williamson Dr., Atlanta
1962

Merry
Christmas

Christmas 1962 our new home on
Williamson Drive, Atlanta

Mount Vernon Woods was one of the first commercially developed neighborhoods in Sandy Springs. Many city dwellers left Atlanta to live the suburban dream of home ownership. (Courtesy of Susan Reid Beard.)

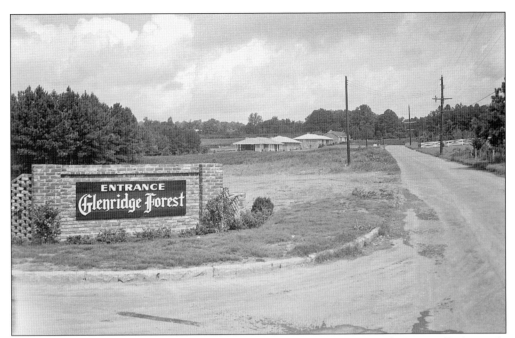

Glenridge Forest was part of the post–World War II building boom in Sandy Springs. Built mostly between 1957 and 1965, the homes were arranged in the new subdivision style that featured similar houses on uniformly sized lots. Today the neighborhood has nearly 500 homes. (Courtesy of Special Collections and Archives, Georgia State University.)

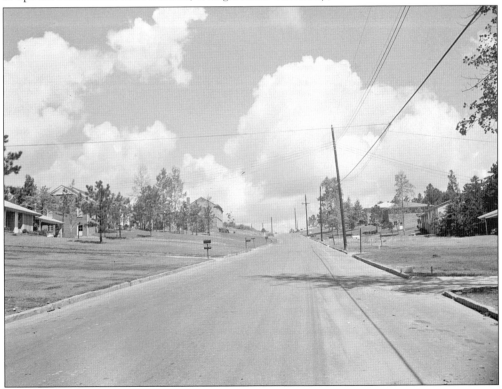

Peggy Langgoth, Oran Creel, and Polly Jones are pictured at the dedication of the Sandy Springs Library in 1965.

Roy and Lorena Bass and their daughter Patricia moved from Highland Avenue in Atlanta to their new suburban dream home in January 1954. Roy owned R. L. Bass, Inc., an insurance company specializing in long-distance truck and bus lines. Along with many of their neighbors, they were members of Sandy Springs Methodist Church. This photograph shows Roy and Patricia Bass enjoying a fun family moment at their home on Mount Vernon Highway. The interior shows how homes changed from rural practicality to middle-class comfort. (Courtesy of Sharon Steele-Smith.)

Northside High School majorette Patricia Bass shows off her new car in this early-1960s photograph. (Courtesy of Sharon Steele-Smith.)

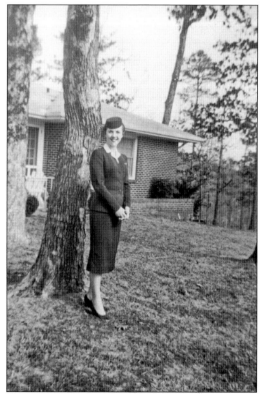

Bass, in her airlines uniform, is pictured outside her parent's home on Mount Vernon Highway. (Courtesy of Sharon Steele-Smith.)

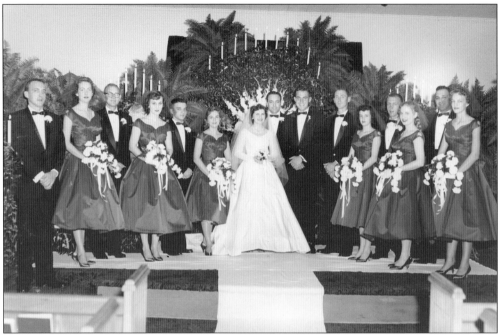

Shirley Foster married Charles Morgan at the Sentell Baptist Church in 1960. Prior to World War II, most couples married at the office of the justice of the peace.

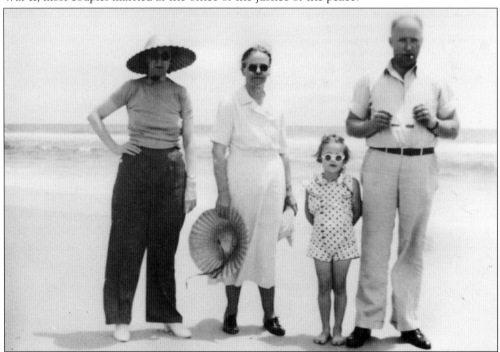

From left to right, Gordon, Dora, Mary Frances, and Henry Mitchell enjoy a family vacation at the beach. With a shift from agricultural based to industrial-type employment, more families in Sandy Springs had disposable income. Increasing prosperity allowed people to enjoy luxuries like travel and vacations.

Three

SCHOOL DAYS

Sandy Springs had few schools in the old days. Most education took place at home; parents who wanted their children formally educated would pay for them to attend subscription schools. Most students attended for less than three or five months a year: this was farmland, and children were needed as hands for planting and harvesting crops during the rest of the year.

In Lois Coogle's *Sandy Springs Past Tense*, Belle Spruell Ezzard tells how her father, Thomas Spruell, with the help of neighbors, built the one-room split-log Hickory Grove schoolhouse close to his home on Roswell Road and Belle Isle. He taught a few neighbors' children through the equivalent of the sixth grade. The school ran for several years. Belle herself attended Mount Paran School, a log building listed as Mount Paran Academy on an 1892 map, where Seaborn Jones taught, although it is not known why she did not attend her father's school (perhaps it was no longer in use by the time she was school aged). There, pupils sat on wooden benches. Planks attached to the rear of the bench in front of them served as a desk. Girls sat on the side of the room where the fireplace was, and the boys sat on the other side, with a wood stove. If it rained, school was canceled. Belle remembered the delight of her mother when at last her children could read the Bible to her; she herself had not enjoyed the opportunity of an education.

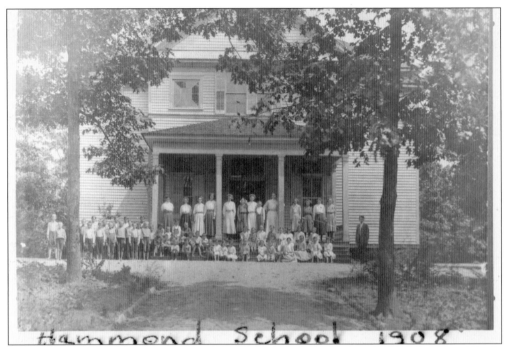

Hammond School 1908

The first school recorded in Sandy Springs appears in the 1851 Deed made to the trustees of Sandy Springs Church "with all the uses and privileges given to a church and a school." This suggests that the church's log building was also used as a subscription school. Above is the Hammond School as it looked in 1908.

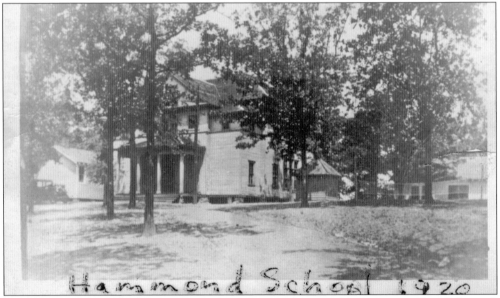

Hammond School 1920

In 1897, the one-room frame schoolhouse directly across from the Sandy Springs Church burned. It was replaced by a four-room, two-story building. The school was named Hammond School for Nathaniel J. Hammond, a prominent lawyer and educator in Fulton County. Students attended for seven months a year—in winter and summer when there was less work on the farm. This photograph shows the school's outbuildings.

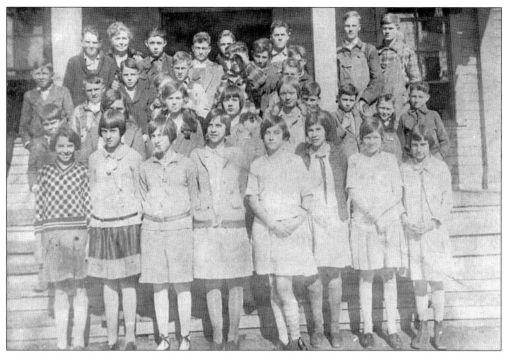

Graduation from school was an honor, especially among rural families that suffered real hardship when able-bodied children were at school instead of working on the farm. The Hammond School class of 1928 was photographed on the front steps of the school building.

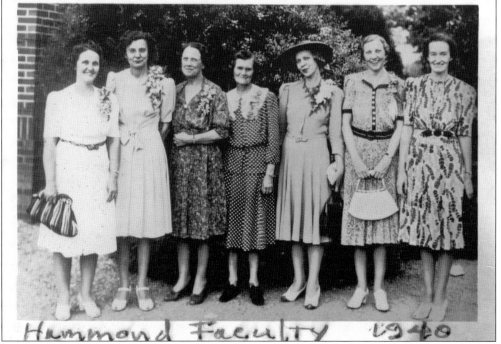

Before World War II, teaching was one of the few careers open to women. This photograph shows the faculty of the Hammond School in 1940.

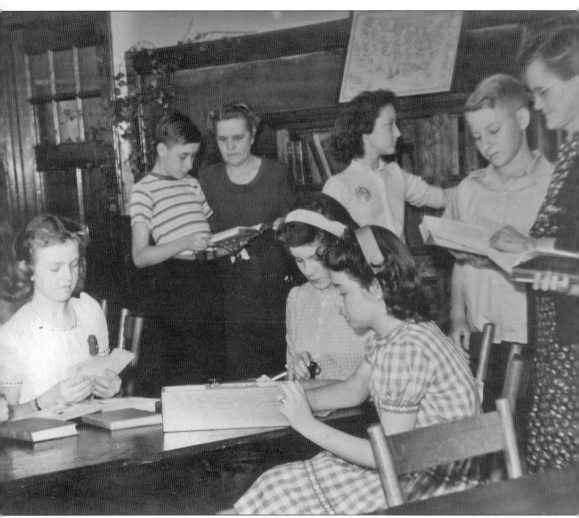

At a time when most families did not own books other than the Bible, the Hammond School had one of the largest libraries in the area. This is a staged photograph, made in 1944. It may have been taken for use by the Fulton County Board of Education. Annie Houze Cook is pictured at far right. (Courtesy of Fulton County Schools Teaching Museum, South.)

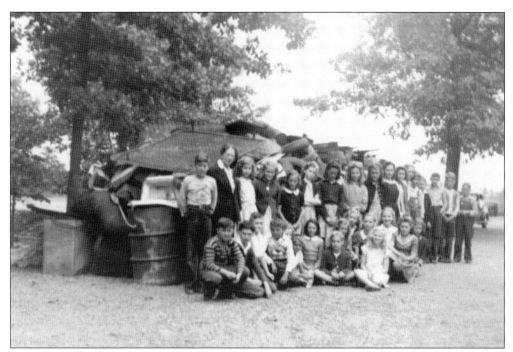

Many local cemeteries and older homes lost ornamental iron fences and gates to the scrap metal drives of World War II. This photograph shows the results of enthusiastic scrap collecting by local students. (Courtesy of Ms. Tiller.)

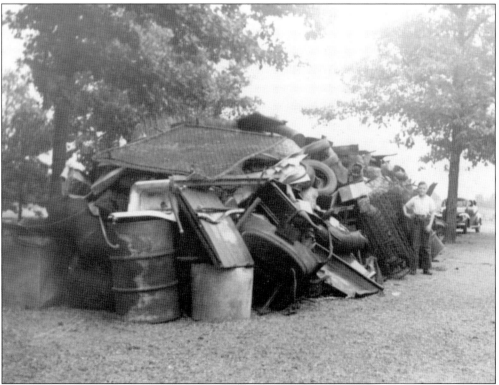

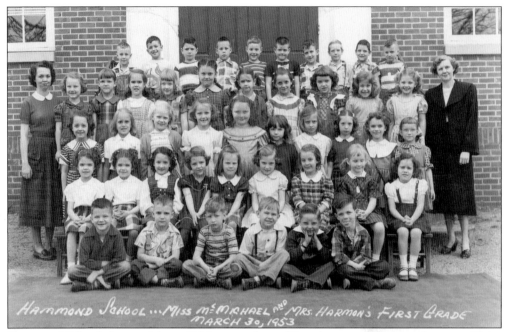

Hammond School alumnus Morris V. Moore explains: "Our classroom was the auditorium. There were only two first grade classes and both are pictured together. The teachers were named Miss Harmon and Miss McMichael. Miss Harmon was my teacher; she was very sweet." (Courtesy of Morris V. Moore.)

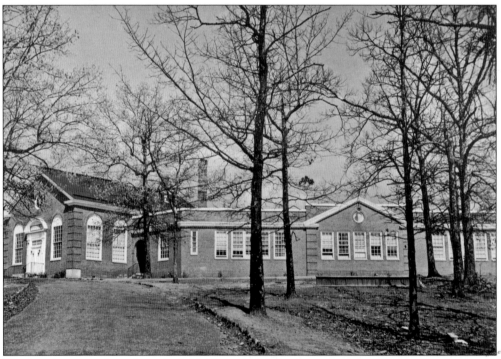

The last class to graduate from the brick Hammond School was the class of 1959. The third of the Hammond School's four homes over the years, this is the building many alumni remember best.

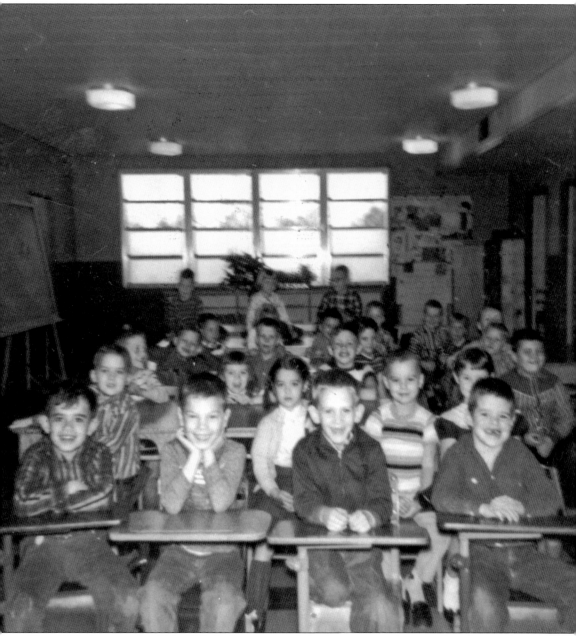

This 1959 photograph of Ms. Tiller's class is one of the few interior photographs taken at the brick Hammond School. The building burned later that year.

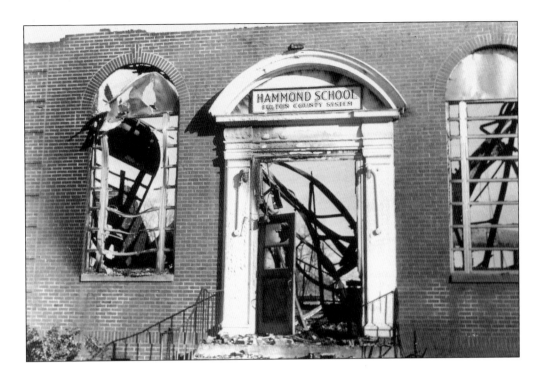

The Hammond School burned in 1959. Fortunately, the fire happened in the evening and no one was injured. Anyone living in Sandy Springs at the time can recall exactly where they were when they heard about the fire.

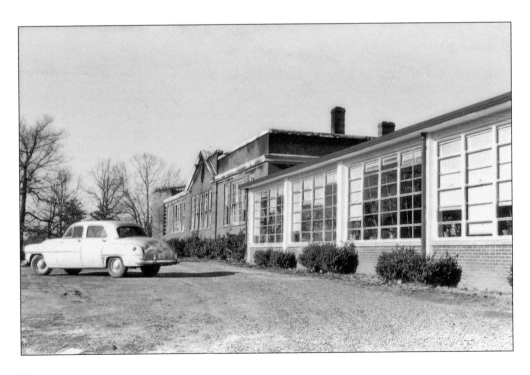

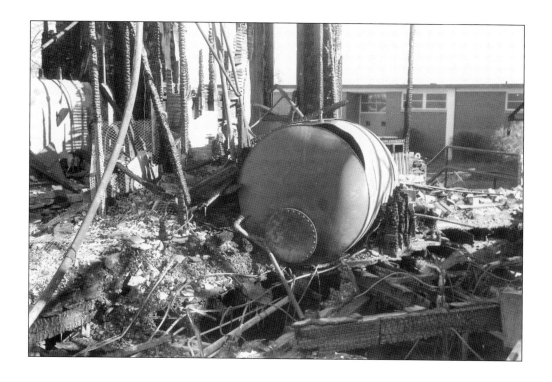

The Hammond School fire remains a landmark event in the community's history. A new school was built on the same site and opened in the early 1960s.

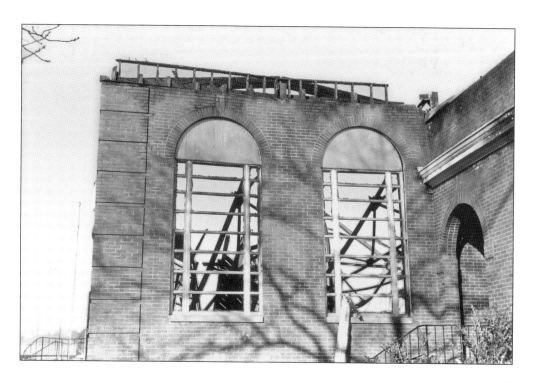

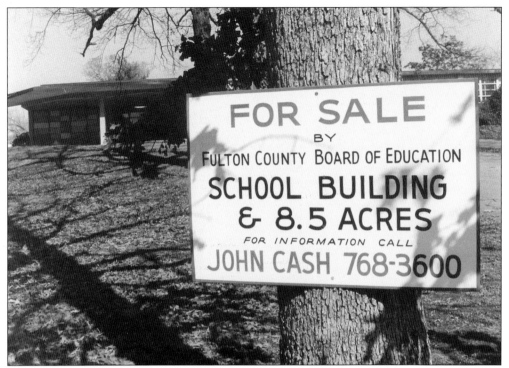

The beloved Hammond School was sold in 1979. It is now the site of Mount Vernon Towers, a residence for active senior citizens, many of whom attended school on the site years before. (Courtesy Fulton County Schools Teaching Museum, South.)

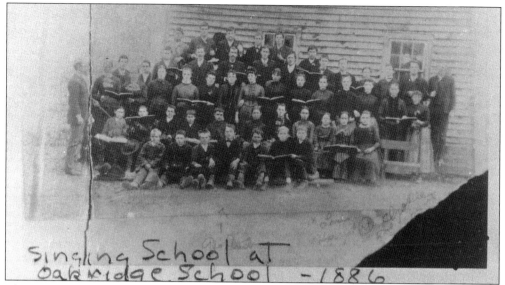

Singing School at
Oakridge School - 1886

This 1886 photograph shows a singing school held by Reuben Ball at the Oak Ridge School. The man at far left may be Mr. Wing, a local singing teacher and photographer. The one-room Oak Ridge School building stood on what is now Spalding Drive, about half a mile from Roswell Road, on property donated by Ball. Reuben's daughter Jessie remembered that her family moved away from the old home place for several years. When they moved back in 1910, she was 16, and the school was gone. Another sister remembers going to school with her cousin there. On the last day of school (set in early spring so that children could help set out crops), everyone in the community attended the end-of-the-year ceremonies. After the recitations, the teacher rewarded all of her students with a stick candy treat.

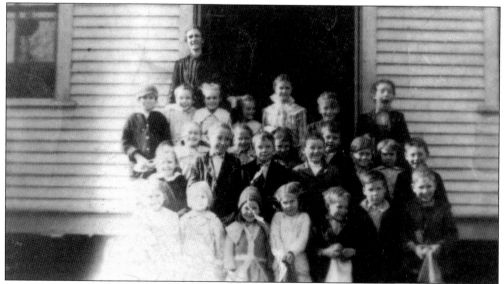

At the intersection of Garmon and Mount Paran Roads was a school called Liberty Hall. It housed about 40 pupils in all grades with one teacher. In 1932, the Fulton County Board of Education consolidated this school with the R. J. Guinn School. The new school was built on Long Island Drive and named Liberty Guinn. The class above was photographed in 1908 at the R. J. Guinn School.

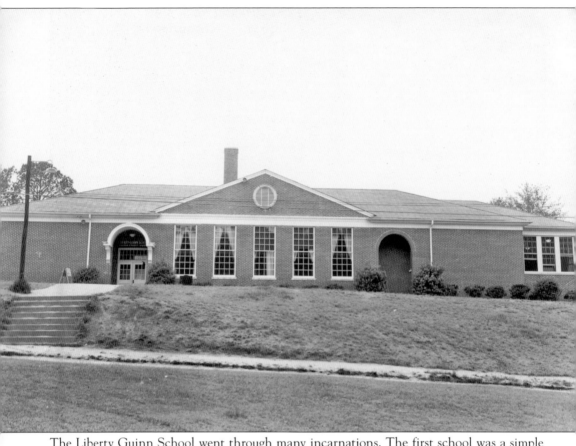

The Liberty Guinn School went through many incarnations. The first school was a simple clapboard-frame building. This brick version of Liberty Guinn dates to the mid-1950s.

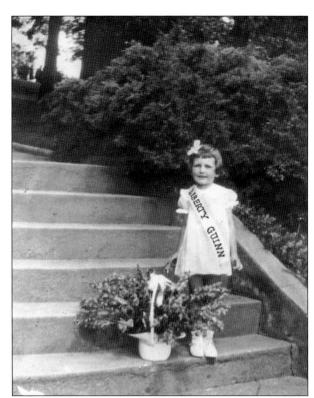

On May 2, 1938, members of the Sandy Springs Parent-Teacher Association presented the governor's wife, Mattie Lucille Lashley Rivers, with flowers as part of the May Day Health Program. Faye Sentell (Fields) represented Liberty Guinn School. She is shown below on the lawn of the Governor's Mansion in Atlanta, Georgia. (Courtesy of Helen Sentell Gilleland.)

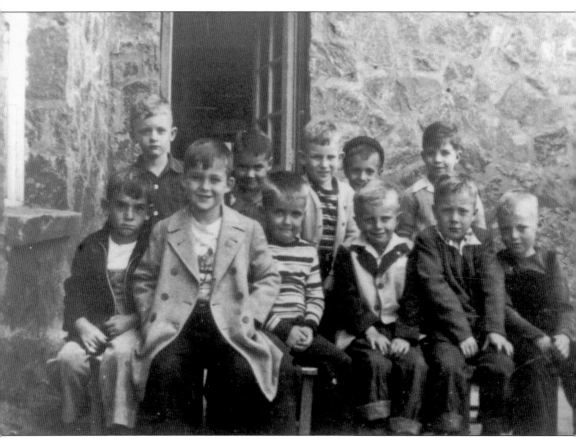

Annie Houze Cook began her teaching career in 1910 at Crossroads, a two-room schoolhouse near the present crossroads of Mount Vernon Highway and Dupree and Powers Ferry Roads. A. A. Jones tells of attending school at Crossroads taught by his father, Seaborn Jones, beneath a brush arbor, with students seated on logs. (When it rained, the school moved to Harris Mitchell's wood shop.) The Crossroads school closed about 1924. Before retirement, Cook taught several generations of students at the Hammond School. After she was forced into retirement by the Fulton County Board of Education, Cook started her own kindergarten at Sandy Springs Providence Baptist Church. This photograph show the new kindergarten, which opened on April 11, 1949.

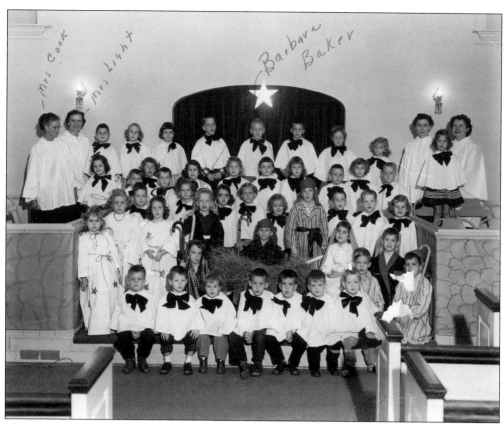

The Annie Houze Cook kindergarten staged a Christmas pageant each December at the Sandy Springs Baptist Church. This photograph was taken in the late 1950s.

The graduating class of the Annie Houze Cook kindergarten poses for a portrait. Kindergarten was not required in Georgia in the 1950s; however, many parents and students felt the Annie Houze Cook kindergarten gave young scholars a great head start on their scholastic careers.

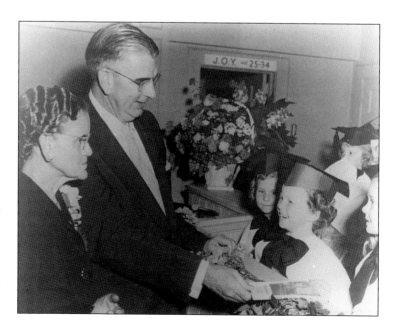

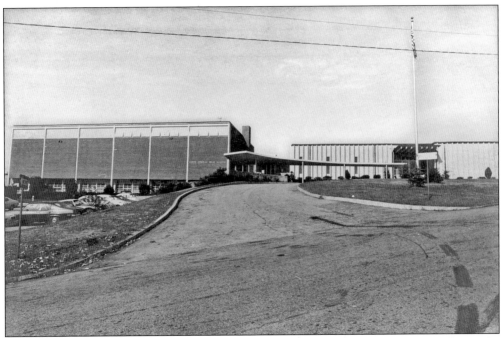

Sandy Springs High School was home to the Panthers athletic teams. Before it opened in 1958, local students attended Northside or North Fulton High School. Currently, Kroger at City Walk occupies the site.

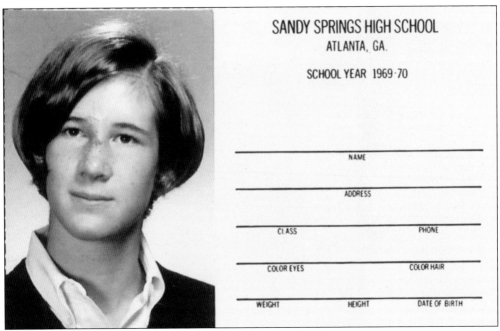

This image is of Susan Reid's Sandy Springs High School identification card. (Courtesy of Susan Reid Beard.)

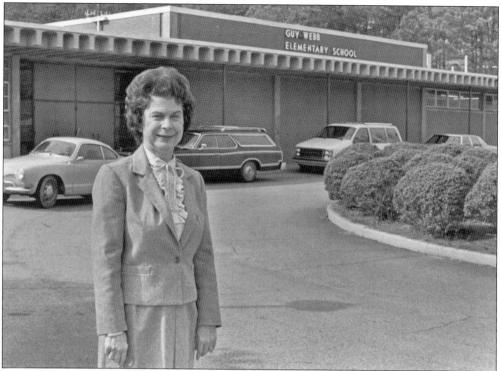

Principal Theodosia Landis stands in front of Guy Webb Elementary School. The school opened in 1959 and was located on Hammond Drive between Glenridge Drive and the Turner-McDonald Parkway. (Courtesy of Fulton County Schools Teaching Museum, South.)

Saint Jude the Apostle School was founded in 1962. Members of the Spalding family donated 10.5 acres of land at Spalding Drive and Glenridge Drive for the school and church. In 1963, the Grey Nuns of the Sacred Heart of Philadelphia began teaching at the school. The first class of 18 students graduated in June 1964. The Grey Nuns staffed the school faculty through the 1970s.

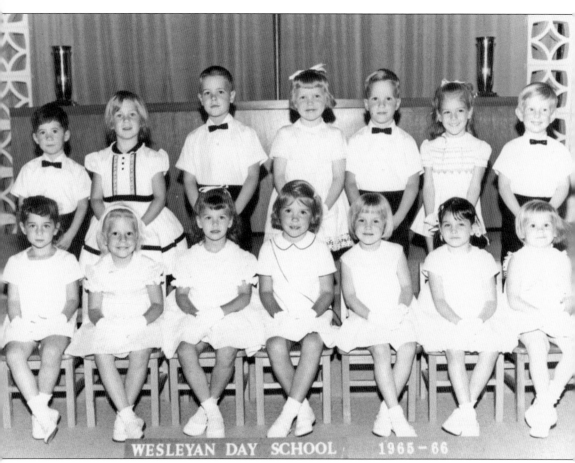

Wesleyan Day School provided kindergarten for many generations of students. The school was held at Sandy Springs Methodist Church. This image shows a graduating class of youngsters from the mid-1960s. (Courtesy of Sharon Steele-Smith.)

Four

RELIGIOUS LIFE

One of the first churches established after the land lottery was the Methodist Church. According to church history, in the summer of 1848 the families of John Austin's sons, William and Franklin Austin, along with James and Wilson Spruill, erected a brush arbor as a meeting place of worship. It was located at the northeast corner of Heards Ferry Road and Lawrenceville Road (later Mount Vernon Highway). For several summers, the small congregation of neighbors worshipped at the arbor.

In 1851, Wilson Spruill donated approximately 5 acres for a new church at the present site of Sandy Springs United Methodist Church. The deed to this property was made out to the first trustees of the church: William Austin, William McMurtrey, James E. Spruill, Stephen Spruill, and William W. Sentell. The boundaries of the acreage were marked by oak, pine, and black jack trees. According to the deed, church members were to have access to the sandy spring. Named after the local landmark, Sandy Springs Methodist Church became the cornerstone of the community's growth.

It is believed a one-room log church was built on the site just inside the present gate of the old cemetery. The building was also used as a school. Members donated logs and rock and hauled them in wagons drawn by oxen. Puncheon benches—half logs with peg legs—were used for pews. The church was lighted by burning pine knots, arranged upright in holes at the end of the benches.

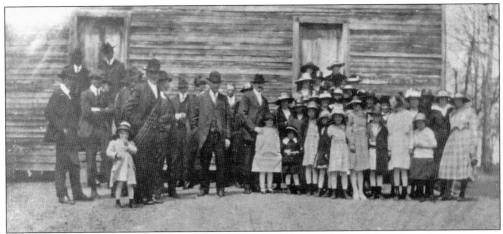

In 1866, the log church was replaced by a frame structure. The frame church was a simple one-room building with a high-pitched roof. Women sat on the right side of the center aisle and men on the left. Will Wait and Charlie Austin donated the church's first organ in 1891.

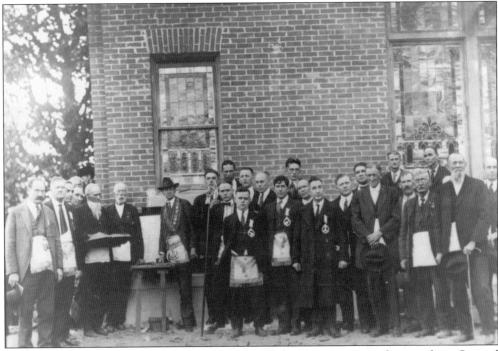

The frame church was used until 1920 when a brick building was erected in its place. Stained windows were placed above the pulpit, given in memory of the founders by their families. Builder J. A. Mabry designed the church uniquely, with pews facing the front doors. In this way, persons coming in late would be observed by everyone present. The embarrassment of the latecomer, hopefully, would encourage punctuality. The cornerstone of the brick church was laid in a ceremony conducted by Charles L. Bass, Grand Master of the Masonic Grand Lodge of Georgia, on October 20, 1921. Members of the building committee were W. H. Mitchell, chairman W. S. Copeland, J. N. Reed, J. A. Reed, L. A. Burdett, J. E. Butler, and M. F. Power. The old brick church was demolished in 1967; the current building stands near its site.

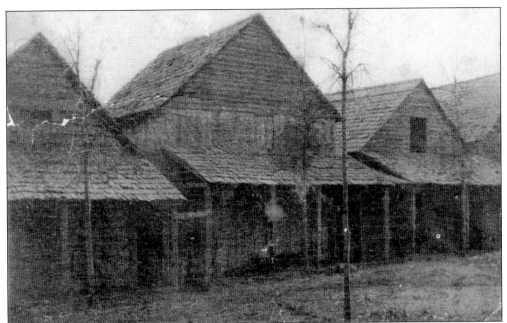

Camp meetings lasted up to five days and featured revival preaching day and night. Persons of all denominations took turns exhorting would-be converts. Not only a time for spiritual renewal, camp meetings were also gathering grounds where isolated farm families and friends could reunite and where the young could do some sparking (courting) on their visits to the springs to fetch water. Camp meetings were festive affairs celebrated annually at a time when crops were laid by, thus providing a reprieve from the rigorous routine of farm life. They were usually the fourth weekend in August. There is no record of the first revival, but an 1864 map used by Union General John Schofield identifies the Methodist Campground. Many families built "tents" around the church and across the road from the arbor. These tents were actually simple wooden cabins built for housing a family for the period of the camp meeting. According to the church history, some of the earlier ones were open-air scaffolds covered with sod. Later they were enclosed and designed with bunks built around three walls.

The above image was made at a camp meeting at Sandy Springs Methodist Church in the 1920s. The group may be at the arbor or under a shed connected to a tent.

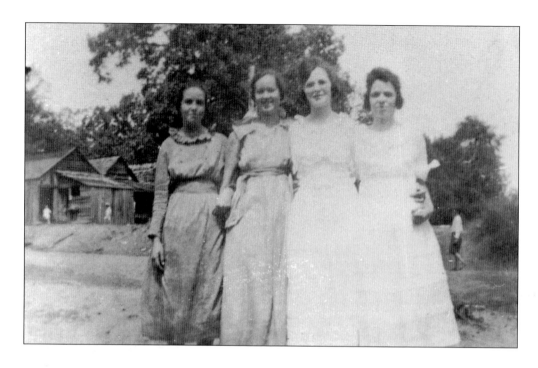

Since the camp meeting was greatly anticipated all year, people made preparations for them in much the same way people today might prepare for a vacation. They took their finest clothes, packed their best food, and brought musical instruments and games to entertain friends between sermons. Tents are visible in the background of both of these *c.* 1920 photographs. Pictured above are, from left to right, Clara, Ella, Flavela, and Evelyn Owens. Below are G. W. and Ella Owens.

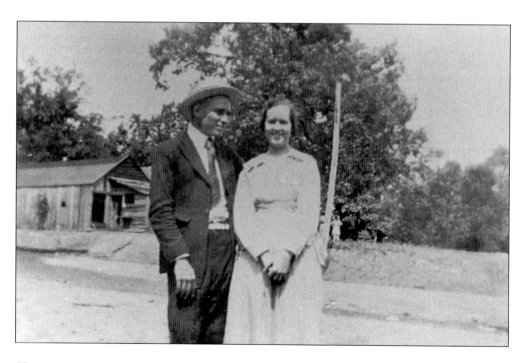

A sister of Aubrey Morris is photographed at the sandy spring site in 1941. No one knows when the first shelter was built over the well, but it kept the spring's site clean for generations. Gourd dippers were kept at the spring, and later metal dippers with red handles were used. (Courtesy of Aubrey Morris.)

Lorene (left) and Elizabeth Swafford are photographed at the spring site in 1942. It appears that a rock or concrete slab has been placed at the spring so visitors can keep their feet dry while dipping water.

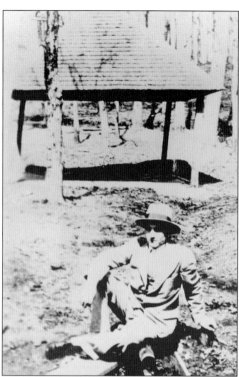

In this 1929 photograph, Cecil Duncan appears to be sitting on a drainage pipe that was installed to divert the spring's water into a collection pond for animals.

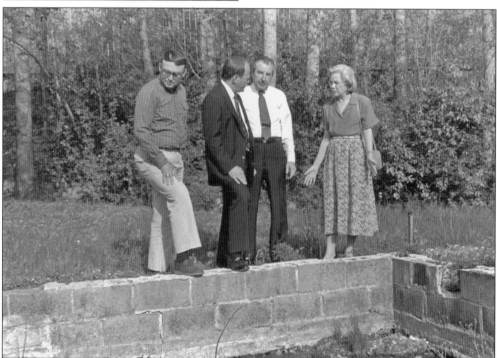

By the early 1980s, the spring had been encased in cement blocks. It was on the property of the Mabry family, who lovingly cared for it over many years. Above, preservationists discuss efforts to save the site from development around 1985.

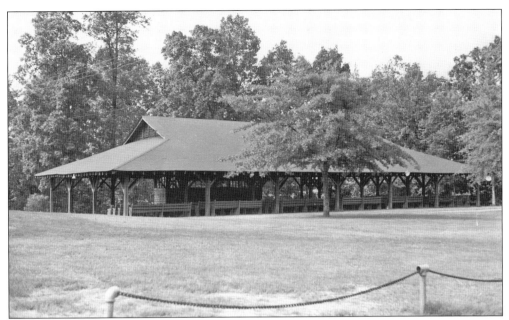

A fire in 1931 destroyed the tents and arbor at Sandy Springs Methodist Church. The larger, more modern structure seen above arose on the same site within the year and was used for open-air services until 1959 when it was removed. The tents were not replaced.

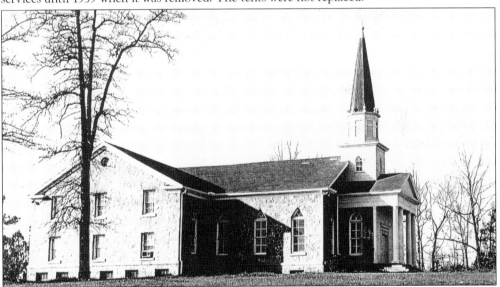

The original Providence Baptist Church was constituted in August 1853 and met in a log cabin located on the property of W. G. Aiken near the present New Hope Cemetery in Dunwoody. In 1878, a church was erected on land donated by I. H. Wilson at the corner of Lawrenceville Road (now Mount Vernon Highway) and Old Roswell Road (now Glenridge Drive). This church building was used for 16 years. In 1894, a frame church was built on this same property. On May 8, 1938, ground was broken and building of the rock church was begun. The building was consecrated in 1942 and used until May 1967 when a new church was constructed a short distance east. The name of the church was then changed from Providence Baptist Church to First Baptist Church of Sandy Springs.

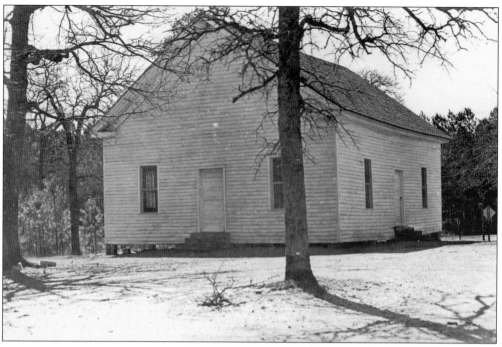

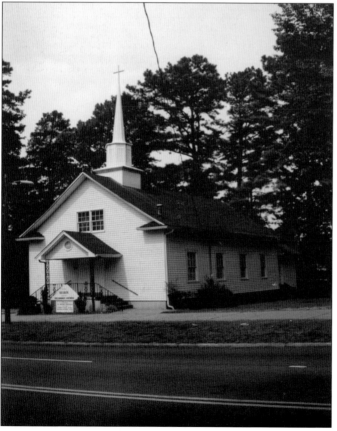

Crossroads Primitive Baptist Church was organized in January 1870. The Mosses, parents of Myrtle Wade, gave the property to the church with the stipulation that if at any time the church dissolved, the property would revert to the family. Nearly 140 years later, the church continues to meet.

Sharon Methodist Church on Dunwoody Place has served the community for more than 100 years.

Sentell Baptist Church was formed in 1914. The cemetery adjoining the church is much older than the church itself. One of the oldest graves belongs to Revolutionary War veteran Briton Sentell who died in 1847. The Sentell Baptist Church ministry was moved to the Georgia Baptist Children's home December 31, 2000.

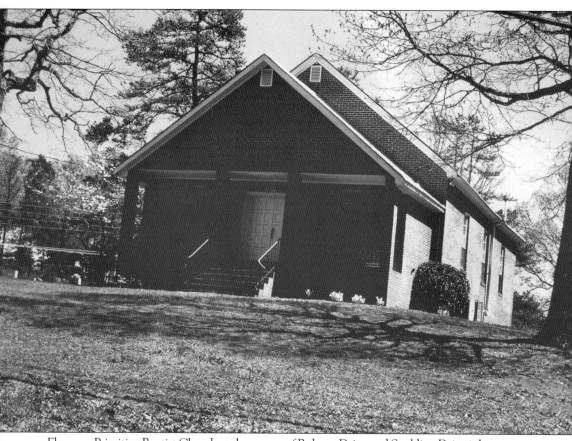

Ebenezer Primitive Baptist Church at the corner of Roberts Drive and Spalding Drive is home to one of the community's oldest congregations, founded in 1829. The cemetery includes a monument that the Dunwoody Preservation Trust placed to commemorate Confederate major Charles A. Dunwody. However, he is not buried there but in the old Roswell cemetery in downtown Roswell.

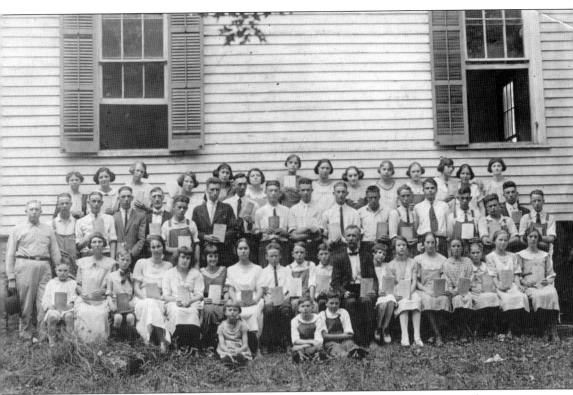

Sacred Harp, also called *fasola* or shape-note singing, emphasizes participation, not performance. The singing is not accompanied by harps or any other instrument. The music is printed in patent notes, wherein the shape of the note head indicates the syllables FA, SOL, LA, and MI.

This late-1950s photograph shows Holy Innocents Episcopal Church and School on Mount Vernon Highway, near the old Crossroads community. During July 1864, heavy fighting took place in this area between the Federal troops attempting to push toward Atlanta and Confederate forces trying to save the city. There have been many other places of worship in Sandy Springs for which there is no photographic documentation: Mount Paran Baptist Church, Mount Vernon Presbyterian Church, Temple Sinai, B'nai Brith, a Unitarian church, Mount Vernon Baptist Church, and Mount Zion Church, to name but a few.

Five

GROWING BUSINESS

Although usually not located inside the community, industry affected Sandy Springs. The grist, saw, and merchant mills of Cobb County and Roswell encouraged steady ferry operations across the Chattahoochee River. Atlanta's growth brought the need for improved roads and rail access. Names of early settlers remain part of the landscape: Abernathy, Hardeman, Heard, Power, Hilderbrand, Burdett, Jett, and Austin, among many others. Sandy Springs does not have a readily discernable central business district: while the city did not grow from a plan or around a central structure like a courthouse or church, Roswell Road is Sandy Springs's main street.

Once a Native American trail called the Wahalla Road, Roswell Road began as a dusty, dirt road that ran from the textile mills of Roswell to Buckhead and then farther on into Atlanta. The crossroads of Roswell Road with Mount Vernon Highway and Johnsons Ferry Road has had several names and postal addresses over the years. Before the Civil War, mail destined for residents of Oak Grove was sent to a store at the corner of Old Roswell Road and Johnson's Ferry. In 1884, the area was designated Hammondville. By 1892, the community was called Hammond and the post office relocated to Acree's store near the present site of the Sandy Springs Library on Johnson's Ferry Road.

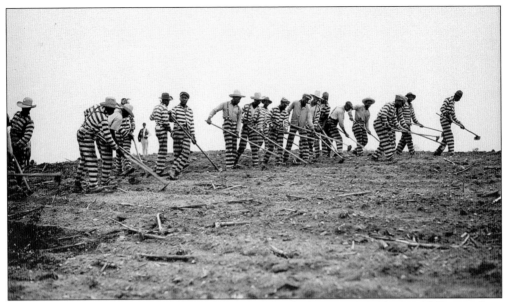

Convicts were an important source of cheap labor for Fulton County and the rest of Georgia from the late 1800s until the early 1940s. A convict camp was located in Sandy Springs on Roswell Road south of Hammond Drive approximately where the Hammond Springs shopping center is located today. Convicts were used to quarry stone from local pits at Lake Forest Drive and Peachtree-Dunwoody Road. Chain gang laborers were also used to build roads, harvest crops, and work in mills. (Courtesy of Special Collections and Archives, Georgia State University.)

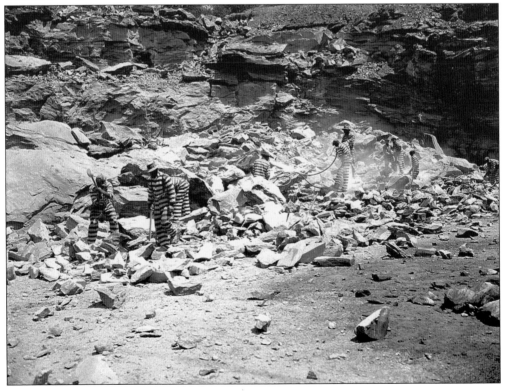

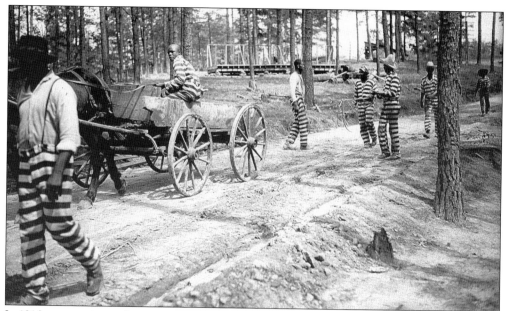

In 1916, an experimental convict camp was built on Powers Ferry Road. After 10 months of research, a report on the findings of the experiment was published as a U.S. Department of Agriculture Bulletin titled "Report on Experimental Convict Road Camp, Fulton County, GA." In the conclusion of their report, researchers determined that the study's results demonstrated that "cleanliness, comfort and humanity in the convict camp are not inconsistent with economy and efficiency in the work of the inmates." In addition to working on Powers Ferry Road, the 40 convicts worked to widen and improve Heards Ferry Road. (Courtesy of Special Collections and Archives, Georgia State University.)

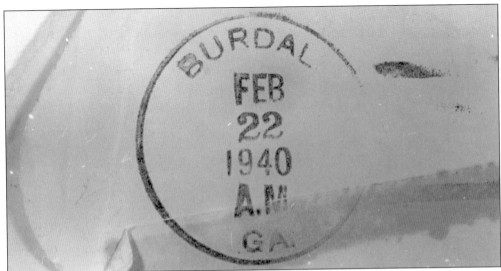

From 1903 to 1925, mail was delivered once a week from Dunwoody; however, in 1925, Burdett's Grocery Store on Roswell Road became the post office for the newly dubbed Burdal—a composite of two area family names, Burdett and Dalrymple. Not until the 1930s and the advent of RFD (Rural Free Delivery) could local residents have their own mailbox instead of traveling to the post office. The name Burdal never caught on, and in 1941, the community's name changed again, to Sandy Springs.

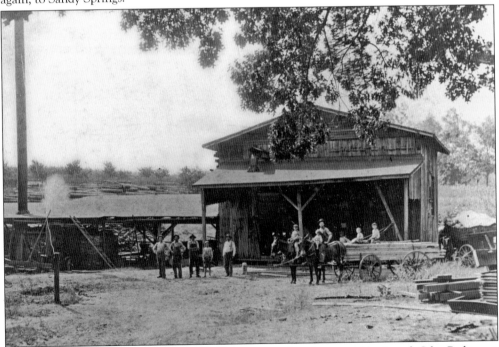

This photograph shows a sawmill and cotton gin owned and operated by Joseph Silas Perkins at Glenridge Drive and Johnson Ferry Road. Sawmills tended to be temporary structures constructed at the most convenient place to process lumber. Once an area had been cleared, the sawmill was dismantled and moved to a more profitable location. Because Sandy Springs had an abundance of wood, sawmills could stay in one place for many years.

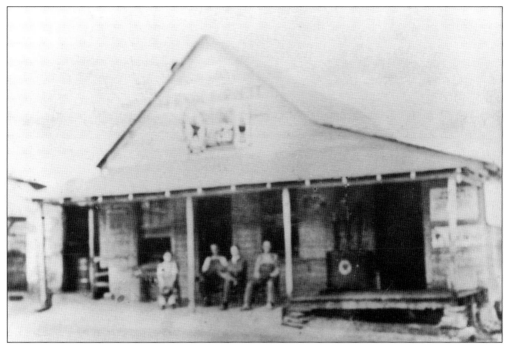

Stephen Burdett built and operated Burdett Grocery at the crossroads of Mount Vernon Highway and Roswell Road. In 1924, his nephew John Franklin Burdett took over the store and ran it for many years. This photograph shows the original frame store.

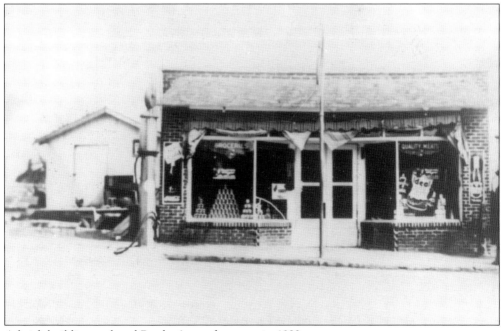

A brick building replaced Burdett's wooden store in 1939.

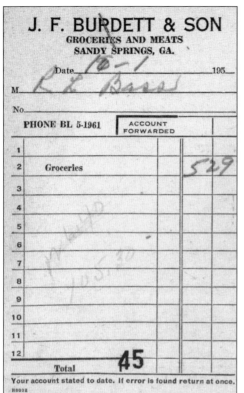

J. F. BURDETT & SON
GROCERIES AND MEATS
SANDY SPRINGS, GA.

Date 10-1 195

M. R. L. Bass

No.

PHONE BL 5-1961	ACCOUNT FORWARDED	
1		
2 Groceries	5 29	
3		
4		
5		
6		
7		
8		
9		
10		
11		
12		
Total	45	

Your account stated to date. If error is found return at once.
N8032

Frank Burdett kept a tab for his customers and billed at week's end. According to Morris Moore, a mischievous child might try to have a piece of candy added to his family's tab during an after-school visit; however, "Mr. Frank" always seemed to know exactly what the children had permission to buy and what was suspect. (Courtesy of Sharon Steele-Smith.)

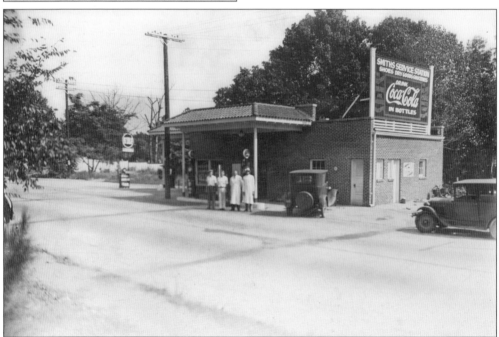

Smith's Service Station at the corner of Roswell Road and Piedmont Road sold shoes, dry goods, and groceries. Here Alan Sentell is pictured at the store in the 1930s. The others are unidentified. (Courtesy of Helen Sentell Gilleland.)

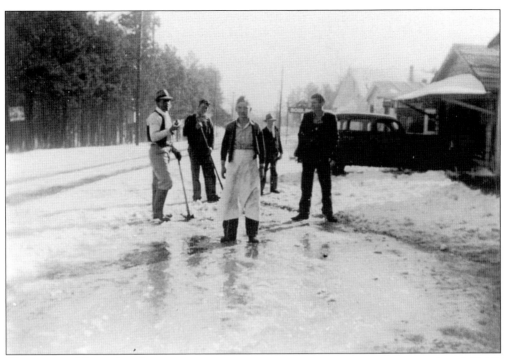

This is one of the earliest known pictures of the Roswell Road business district. No doubt the image was meant to capture a rare occurrence in Sandy Springs: snow. Both of the images on this page were taken at the same time and may document the historic snowfall of 1940. The view shows Roswell Road looking south between Mount Vernon Highway and Hilderbrand Drive. The bowling alley is in the background at far right. Dr. Griffith's Pharmacy and J. B. Ficklin's Filling Station may be the other two structures. The photograph dates from the 1930s or early 1940s.

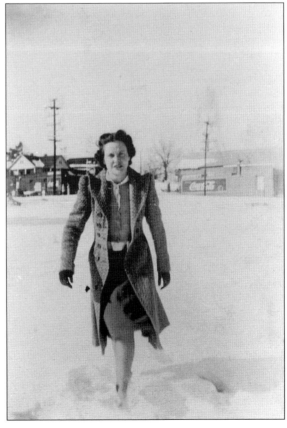

A young woman enjoys the snow in this rare photograph of old Sandy Springs. Roswell Road is behind her, and she is walking toward Hammond Drive. Burdett's Grocery Store with a Coca-Cola sign painted on the side and Taylor's Department Store are in the background.

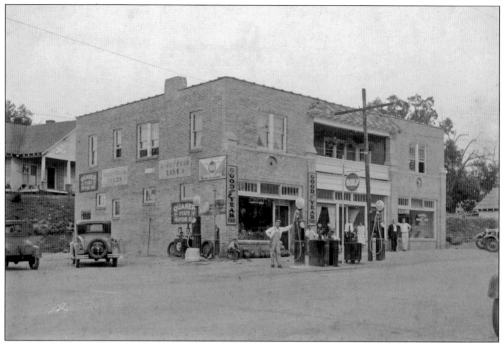

Robert Nesbitt Hardeman and his wife, Thelma, opened a general store in the 1920s at the corner of Mount Vernon Highway and Roswell Road. The building also housed the Roy Lewis Barbershop. Currently, Master Kleen laundry occupies the site.

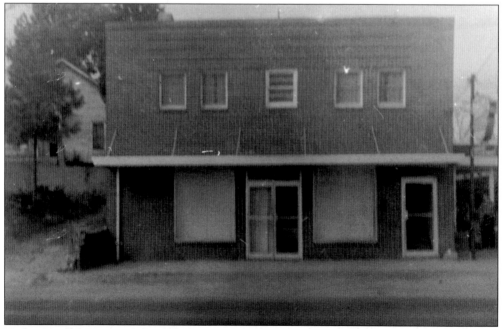

Nesbitt Hardeman's next business venture was the Sandy Springs Hardware Company (commonly known as Hardeman's Hardware), located midway between Mount Vernon Highway and Johnson Ferry Road on Roswell Road. It is the current location of Psycho Tattoo. The hardware store operated until 1958.

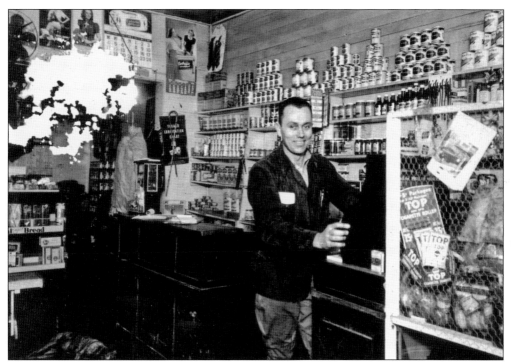

Above, Ted Gentry is photographed at his store on Mimosa Boulevard in Roswell about 1945. His store was one of the closest places for most Sandy Springs residents to purchase ice. He would also deliver ice in 25- or 50-pound blocks for people that owned iceboxes or refrigerators. The other option was to travel to the ice store in Buckhead at the corner of Pharr Road and Peachtree Road.

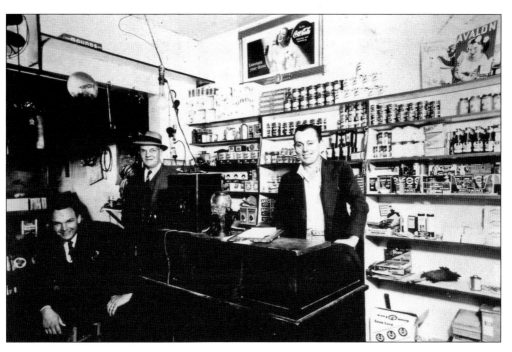

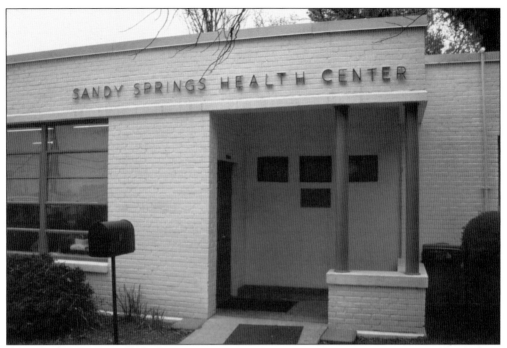

The Sandy Springs Health Center, built in 1948, still serves local citizens. Located on Johnson Ferry Road, the center was often a first stop for students getting vaccinations and immunizations before starting first grade. Nurse Murphy served as a primary source of health care for many children.

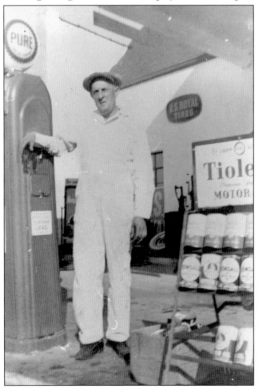

George Nance is photographed at his service station at the corner of Mount Vernon Highway and Roswell Road in 1949. The Nance family moved to Sandy Springs in 1911 and owned approximately 15 acres of land near the current location of the Dorothy Benson Senior Center near Mount Vernon Woods Drive. The Nance family, like many others, sold extra produce to the markets in downtown Atlanta.

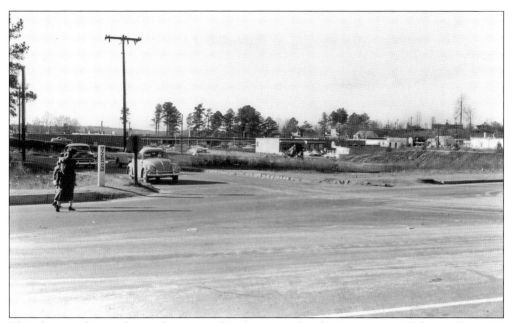

This photograph was taken at the corner of Boyleston Road and Mount Vernon Highway. The newly built Sandy Springs Shopping Center and the old Sandy Springs ball field are in the background. This photograph taken by Richard Coleman about 1959. (Courtesy of Morris V. Moore.)

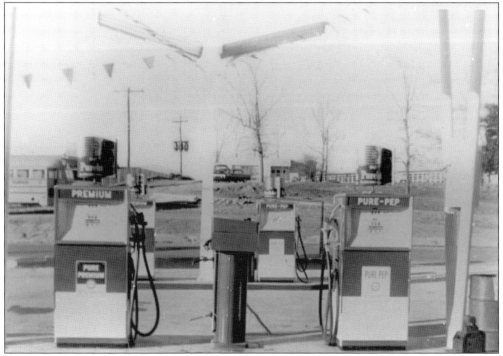

Gas stations often provided an informal gathering place for men of the community. Located at Mount Vernon Highway and Boyleston Road, Nance Pure Oil offered gasoline, car service, and conversation. In this c. 1955 photograph, the Hammond School and the Health Center stand in the background.

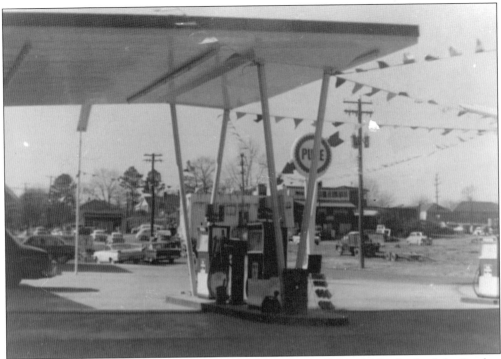

This photograph of Nance Pure Oil was taken facing Roswell Road. The back of the Burdett Grocery Store is visible in the background. The image was likely made in the mid-1950s.

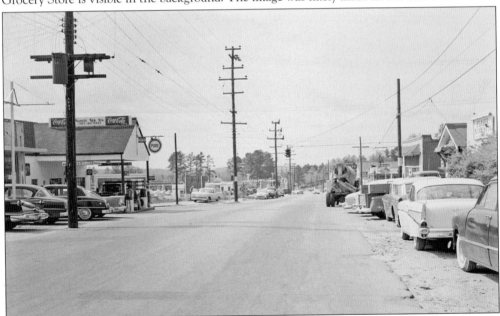

This photograph looks south down Roswell Road at the intersection of Mount Vernon. On the left is the corner of Burdett's Grocery Store, with George Nance Pure Oil next door. On the right are Fraser Plumbing and Heating Company, the Roy Lewis Barber Shop, and Taylor's Department Store. The image was taken in the 1950s. (Courtesy of Special Collections and Archives, Georgia State University.)

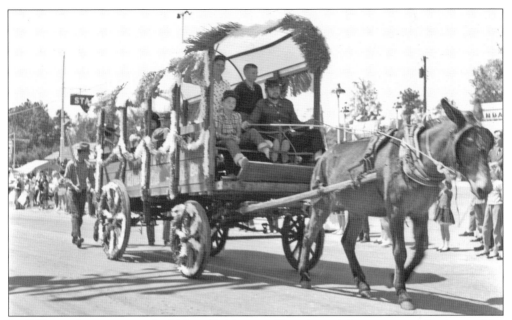

In 1958, a mule train carried gold from Dahlonega, Georgia, to Atlanta to cover the dome of the Georgia State Capitol Building. The procession passed through Sandy Springs on Roswell Road. On the geological map, the Georgia gold vein runs from the northern mountains south into the Sandy Springs area. There have been several gold mines in Sandy Springs, but none have yielded a significant amount of treasure.

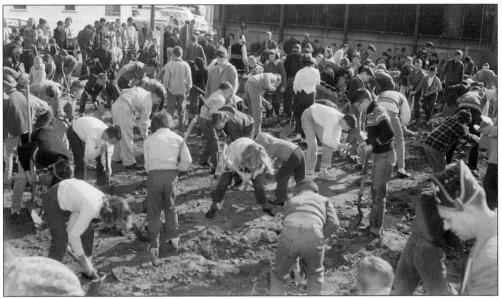

Groundbreaking for the First Federal Savings and Loan building was a major event in Sandy Springs. Local children were digging for treasure (a hidden token for a bicycle). The white frame building in the background was at one time the Sandy Springs a short-lived bowling alley and later a post office. Across Roswell Road is Burdett's Grocery Store and new construction. Currently, Starbucks Coffee occupies the building. (Courtesy of Special Collections and Archives, Georgia State University.)

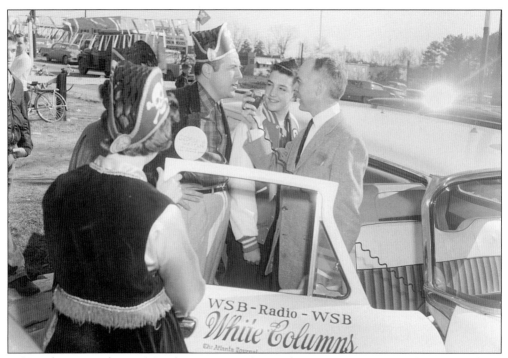

WSB radio personality and Sandy Springs resident Aubrey Morris interviews the treasure hunt winner on a live broadcast. Aubrey Morris worked as a noted journalist for the *Atlanta Journal* newspaper and held many titles including: news director, public affairs director, and editorial director for WSB radio and television. He is a descendent of James Jett, who came to Sandy Springs in 1818. (Courtesy of Special Collections and Archives, Georgia State University.)

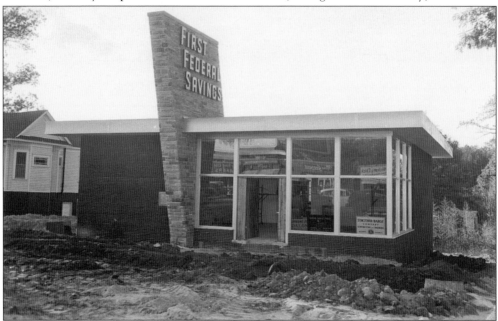

Sandy Springs's First Federal Savings and Loan building currently houses Starbucks Coffee. (Courtesy of Special Collections and Archives, Georgia State University.)

This photograph of Roswell Road near Glenridge Drive in the early 1960s shows the area as it was just beginning to ripen for the development of neighborhoods and schools. (Courtesy of Special Collections and Archives, Georgia State University.)

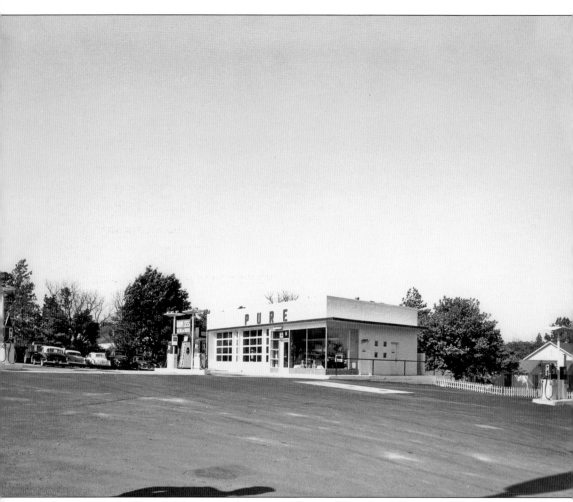

At one time the Pure Oil Station at the corner of Roswell Road and Hammond Drive was owned by Jake Wilson. It is unknown if he owned the station when this photograph was taken in the mid-1960s. Currently, the Payless Shoe store is on the site. (Courtesy of Special Collections and Archives, Georgia State University.)

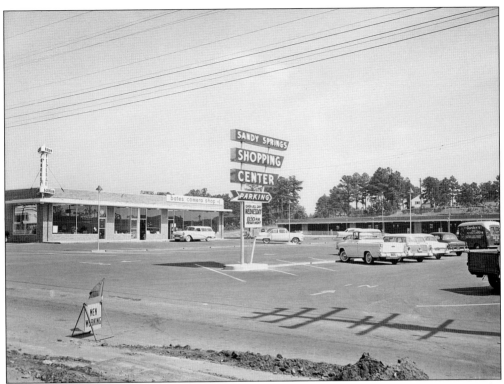

The Sandy Springs Shopping Center opened in the late 1950s on Roswell Road. It housed the community's first super market, Big Apple. Note the sign which reads: "Open all Day Wednesday." In the South, most stores were only opened a half-day on Wednesday. Shop owners and employees worked on Saturdays and needed time off during the week. (Courtesy of Special Collections and Archives, Georgia State University.)

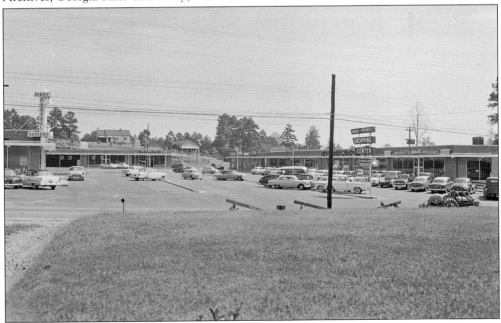

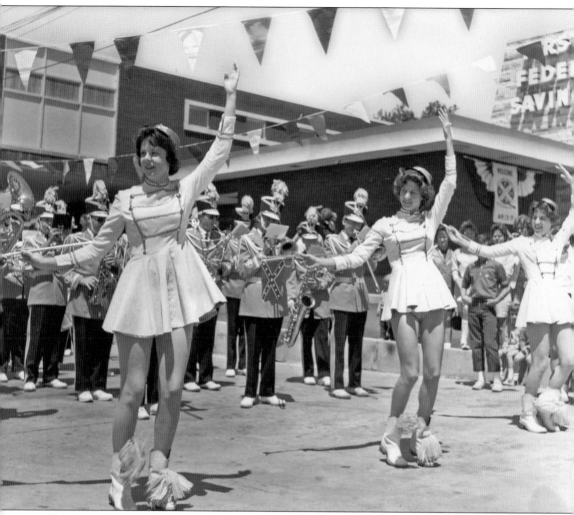

The Sandy Springs High School marching band and majorettes are pictured on Roswell Road about 1963–1964. The First Federal Bank building (currently Starbucks) is in the background. Sally Schaefer is the center majorette.

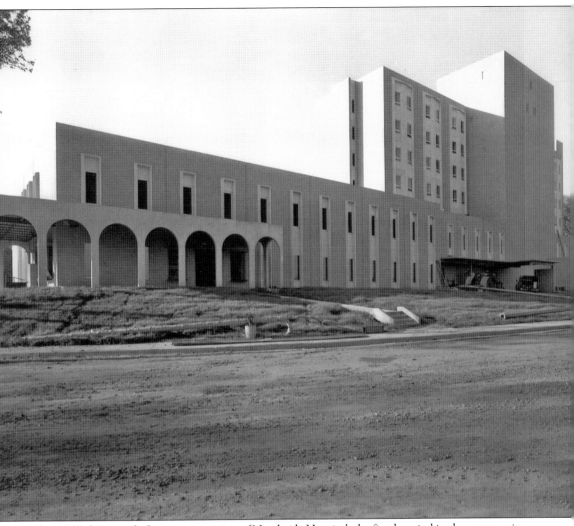

This 1969 photograph shows construction of Northside Hospital, the first hospital in the community. Before it was built, Crawford-Long and Piedmont Hospitals were the closest medical facilities, and famed pediatrician Dr. Lela Denmark practiced medicine from an office in her Glenridge Drive home, near the present site of the hospital. The Bondurant House occupied the site for many years before construction began.

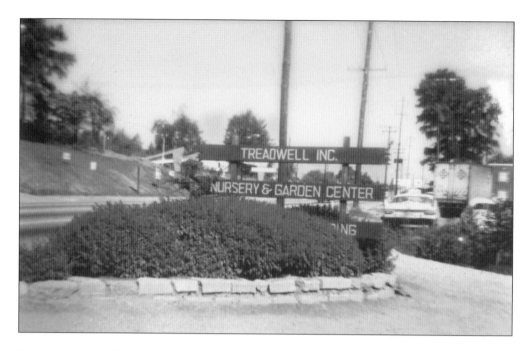

Located on Roswell Road just south of the Northside Tower, Treadwell's was a popular local nursery and garden center. In the background of the picture above, the arches on the hill belong to one of the first fast-food restaurants in the area, Carroll's Hamburgers. The image below shows Mr. Treadwell at the Sandy Springs High School hangout, the Panther Drive-In.

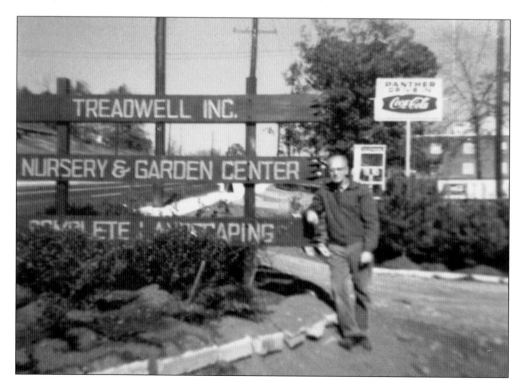

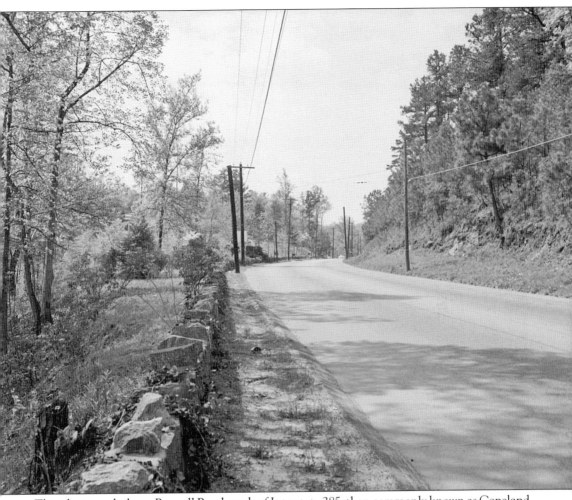

This photograph shows Roswell Road south of Interstate 285, then commonly known as Copeland Hill. The wooded area to the right is the current location of the Prado Shopping Center, which includes Target and Five Seasons Brewery. (Courtesy of Special Collections and Archives, Georgia State University.)

Above is Roswell Road as it looked in the early 1950s. A Pure gas station and a few other business signs appear in the background. (Courtesy of Special Collections and Archives, Georgia State University.)

Nearly traffic-free in the 1950s, this view of Roswell Road (looking south near Carpenter Drive) is frequently a traffic jam today. When this photograph was taken, Interstate 285 had not been constructed, and Roswell Road was still a country road. (Courtesy of Special Collections and Archives, Georgia State University.)

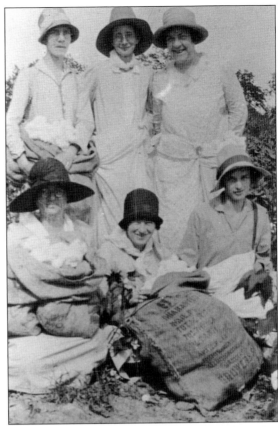

Clubs have always been important social outlets in Sandy Springs. One of the earliest was the Home Demonstration Club. The women in the club shared information about improved canning, sewing, and gardening techniques. They are shown at right in 1926 picking cotton in a field on Glenridge Drive. From left to right are (first row) Minnie Dewald, Mrs. Lawrence Kaufman, and Mrs. J. F. Burdett; (second row, standing) Mrs. Charles Jackson, Maggie Acree, and Nell Glass. Below, the Sandy Spring Women's Club held several fundraisers to support the construction of a permanent library in 1964.

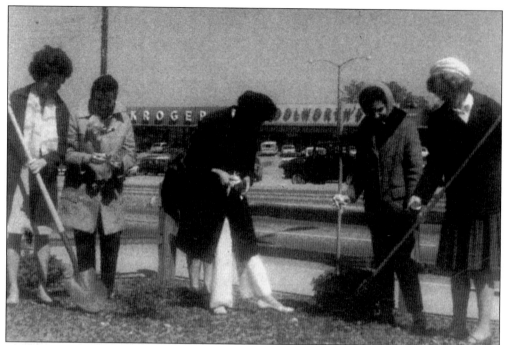

In addition to beautification, Garden Clubs were some of the first local advocates of environmental protection. Here members of the Wyndam Hills Garden Club work to beautify Roswell Road in 1969.

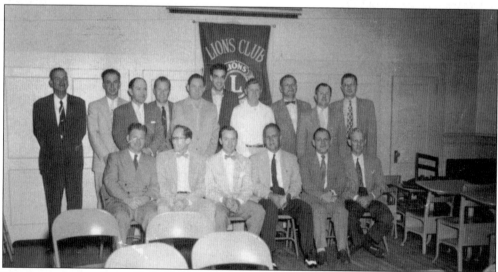

The Sandy Springs Lions Club is part of the world's largest service club organization with over 1.4 million members worldwide. Since 1925, when Helen Keller addressed the Lions and asked them to be "Knights of the Blind," the main focus has been to work with the blind and sight-impaired individuals in communities around Sandy Springs. Since 1954, the Sandy Springs Lions have led numerous fund-raising projects to support Lions Club charities, including the Georgia Lions Lighthouse Foundation, the Georgia Lions Camp for the Blind, and the Children's Eye Center at Emory University. This photograph shows an early Sandy Springs Lions Club meeting. (Courtesy of Sharon Steele-Smith.)

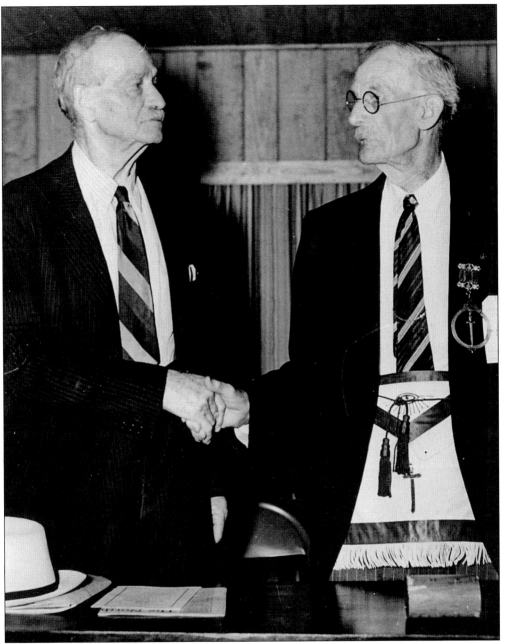

Following World War II, there was a great increase in interest and membership in Freemasonry. At the same time, metropolitan Atlanta began to experience population growth. In 1946, many Masons lived in the Sandy Springs area but were members of other lodges. On January 14, 1947, about 60 of these Masons held a formal meeting in the Hammond School auditorium, chaired by Brother J. Tillman Morgan. During 55 years of existence, Sandy Springs Lodge has contributed much to the community with civic and charitable actions—many of them unpublicized. The lodge has welcomed hundreds of visiting Masons from other lodges and jurisdictions, and has been a source of counsel and comfort to over 700 member Masons. Pictured are Lon Burdett and Tommy Thomason. (Courtesy Mike Lynch and Sandy Springs Lodge 124 F&AM.)

Since January 1972, the Sandy Springs Rotary Club has provided scholarships through the creation of the Dan Keels Scholarship Fund, warm clothing through Coats For Kids, and Christmas gifts for those in need. The Sandy Springs chapter has received many awards from Rotary International, including Best All-Around Club (1997–1998 and 1998–1999), Club of the Decade (2000), and Runner-up Best All-Around Club (2004–2005).

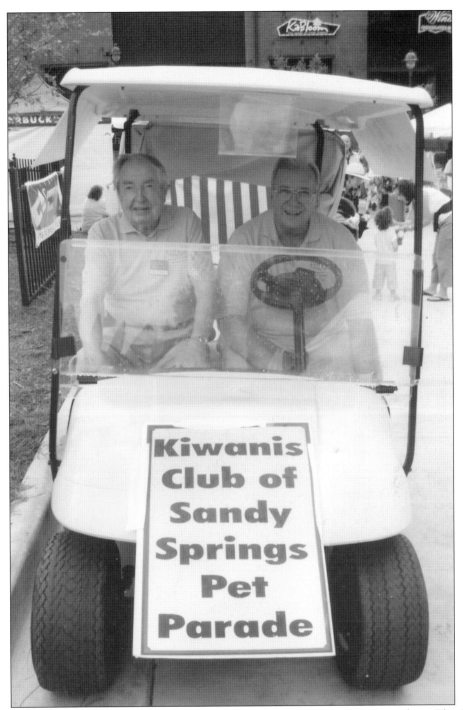

The Sandy Springs Kiwanis Club was chartered on April 1, 1942, with 25 members. The first president was Bill Reed; the second was Jake Denmark. Charlie Shepherd was inducted as president on December 1, 1953. In addition to supporting numerous charitable and community events, the Sandy Springs Kiwanis Club hosts the Pet Parade at the Sandy Springs Festival. Above, Herb Daws and Guy Berger marshal the 2007 Pet Parade.

In 1941, a group of civilian airmen foresaw general aviation's potential to supplement America's military operations. On December 1, 1941, just days before the Japanese attacked Pearl Harbor, these men banded together as the Civil Air Patrol (CAP), dedicated to assisting the Army Air Corps. By Presidential Executive Order, the CAP became an auxiliary of the Army Air Forces in 1943. (Courtesy of Brian Berry and Michael A. Reed.)

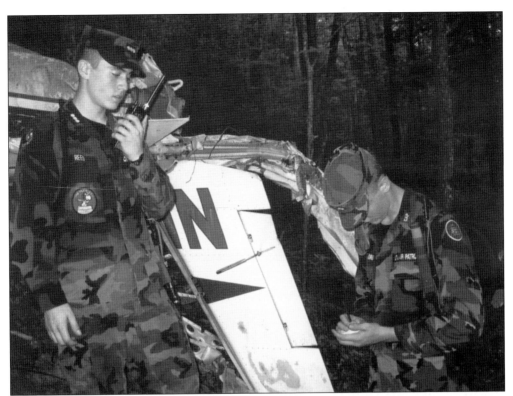

Over the years, Sandy Springs Civil Air Patrol has participated in numerous search and rescue missions, including the rescue of a 14-year-old girl in 1989. CAP's Cadet Programs boast a championship-winning Color Guard and have won the Ron Bradford Cadet Academic Bowl. In emergency services, Sandy Springs Civil Air Patrol is still the go-to unit for excellence in ground operations. In 2006, they were credited with finding the wreckage of legendary test pilot Scott Crossfield's airplane. (Courtesy of Brian Berry and Michael A. Reed.)

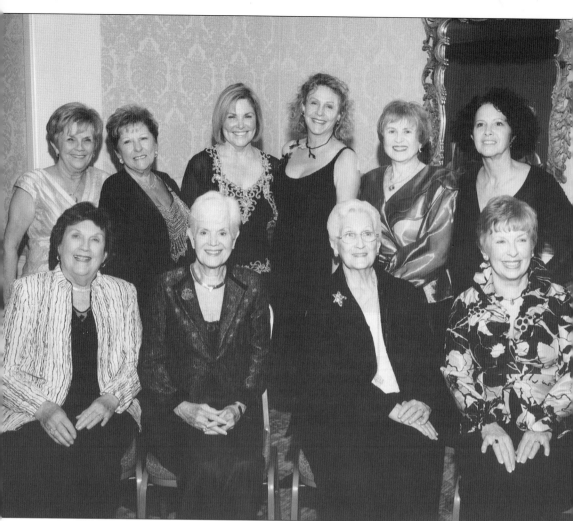

Since its incorporation in 1988, the Sandy Springs Society has grown into the largest single philanthropic agency in Sandy Springs. The Sandy Springs Society is a membership organization composed of dedicated volunteers committed to raising funds that benefit the community. All funds raised by the Sandy Springs Society are granted annually to organizations that support programs that enrich the lives of Sandy Springs residents in the areas of education, arts, environment, heritage preservation, and social services. In this January 2009 photograph, the founding members of the Sandy Springs Society celebrate at the organization's annual gala.

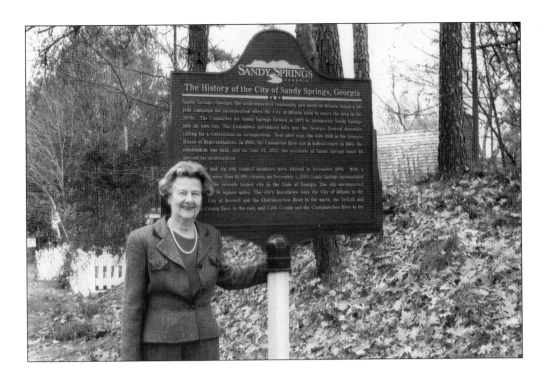

Incorporated in December 2005, Sandy Springs is home to 98,000 residents, making this Georgia's sixth-largest city and the second-largest city in the metro Atlanta area. Above, Mayor Eva Galambos is pictured next to the historic marker commemorating the city's first birthday. The marker was donated by Leadership Sandy Springs and is located on Sandy Springs Circle at Heritage Green.

We're Voting **Yes!** for **Sandy Springs**

JUNE 21st, 2005

www.arcadiapublishing.com

MAP SEARCH

Discover books about the town where you grew up, the cities where your friends and families live, the town where your parents met, or even that retirement spot you've been dreaming about. Our Web site provides history lovers with exclusive deals, advanced notification about new titles, e-mail alerts of author events, and much more.

MADE IN THE USA

Arcadia Publishing, the leading local history publisher in the United States, is committed to making history accessible and meaningful through publishing books that celebrate and preserve the heritage of America's people and places. Consistent with our mission to preserve history on a local level, this book was printed in South Carolina on American-made paper and manufactured entirely in the United States.

This book carries the accredited Forest Stewardship Council (FSC) label and is printed on 100 percent FSC-certified paper. Products carrying the FSC label are independently certified to assure consumers that they come from forests that are managed to meet the social, economic, and ecological needs of present and future generations.

FSC
Mixed Sources
Product group from well-managed forests and other controlled sources

Cert no. SW-COC-001530
www.fsc.org
© 1996 Forest Stewardship Council

Find Your Place in History.